For as long as there has been art, there has been discussion about art. Over the past two centuries, as ideas and movements have succeeded each other with dizzying speed and the debate between various aesthetics has turned increasingly vivid, art criticism and theory have taken on an unprecedented relevance to the development of art itself.

ARTWORKS restores to print the most significant writings about art—whether letters and essays by the artists themselves, memoirs and polemics by those who lived with them in the thick of creation, or illuminating studies by some of our most prominent scholars and critics. Many of these works have long been unavailable in English, but they merit republication because the truths they convey remain valid and important. The list is eclectic because art is eclectic; taken as a whole, these titles reflect the history of art in all its color and variation, but they are bound together by a concern for their importance as primary documents.

These are writings that address art as being of both the eye and the mind, that recognize and celebrate the constant flux in which creation has occurred. And as such, they are crucial to any understanding or criticism of art today.

CONCERNING THE SPIRITUAL IN ART

WASSILY KANDINSKY

in the original translation by Michael T. H. Sadler

with a new introduction by Adrian Glew

and previously unpublished letters and poems by the author

MFA PUBLICATIONS
a division of the Museum of Fine Arts, Boston

MFA PUBLICATIONS
a division of the Museum of Fine Arts, Boston
465 Huntington Avenue
Boston, Massachusetts 02115
www.mfa-publications.org

Originally published in 1911 as *Über das Geistige in der Kunst* by Piper Verlag,
Munich. This translation was first published in 1914 by Constable and Company
Ltd., London, under the title *The Art of Spiritual Harmony*. The present edition is
published by arrangement with Tate Publishing, London.

For a complete listing of MFA Publications, please contact the publisher at the
above address, or call 617 369 3438.

ISBN 0-87846-702-5
Library of Congress Control Number: 2006922385

Available through D.A.P. / Distributed Art Publishers
155 Sixth Avenue, 2nd floor
New York, New York 10013
Tel.: 212 627 1999 · Fax: 212 627 9484

FIRST EDITION
Printed on acid-free paper
Printed and bound in the United Kingdom

INTRODUCTION
Adrian Glew

Wassily Kandinsky's ground-breaking theoretical publication *Über das Geistige in der Kunst* first appeared in German in 1912 before being translated into English by Michael Sadler as *The Art of Spiritual Harmony* (now known as *Concerning the Spiritual in Art*) in 1914. This introduction traces the efforts of both author and translator to ensure that the book appeared in print and goes on to consider its impact among English-speaking artists at the time. The story behind the translation of key art-historical texts and their subsequent influence can be as illuminating as the genesis of the original tracts themselves. Sometimes translations materialise through chance developments, but in Kandinsky's case the opportunity to translate his work into English was conscientiously pursued. Whatever their derivation, their publication can change precepts and concepts forever, and so alter the course of subsequent enquiry.

An early example of such a tract is *De architectura* (*On Architecture*), the original written by the Roman architect Vitruvius around 27–23 BC, and a manuscript copy rediscovered by the Florentine Poggio Bracciolini in 1414. It survives as the only contemporary source on classical Roman architecture, with the first printed edition published by Fra Giovanni Sulpitius in 1486. Its appearance helped to revive an interest in classical cultural and scientific heritage. The fifteenth-century Italian architect Palladio, for instance, took much of his inspiration from Vitruvius, basing his own architectural designs on the master's work. Although Italian and German translations were in circulation by the early 1520s, it was not until 1791 that a full translation of all ten volumes was published in English.[1] Once translated, British architects such as Inigo Jones understood its significance immediately; he was among the first to re-evaluate and put into practice Vitruvius's stress upon number and proportion.

Giorgio Vasari's *Delle vite de' più eccellenti pittori, scultori, e architetti*, simply known in English as the *Lives of the Artists*, comprises over one hundred biographies of painters, sculptors and architects living and working in Italy between the thirteenth and fifteenth centuries. Never before had a writer on such a subject divided the arts into periods and styles. Published for the first time in 1550 it was peculiarly, for the period, written in Italian rather than Latin. In 1846, a certain Mrs Foster, of whom little is known, then translated the book into English. So began a greater awareness and comparison of artists of the Renaissance, their patrons and their work, which had a profound impact on the discipline of art history from

that point onwards. The *Lives* became a classic and the production of special editions, such as Gaston de Vere's translation published by the Medici Society in 1912,[2] only increased awareness.

Now with the recent cataloguing in the Tate Archive of Sir Michael Ernest Sadler's papers relating to his art collection and of his son's art-related correspondence,[3] the full story of the genesis of the English translation of Kandinsky's *Über das Geistige in der Kunst* can be revealed.[4] Sir Michael Ernest Sadler was a noted educational reformer before moving into academe. His son Michael T. H. Sadleir adopted the older spelling of the family name at an unspecified date, to avoid confusion between his father and himself. He became a successful novelist, publisher and bibliographer. Although Kandinsky's letters to the Sadlers are primarily concerned with practical matters relating to *Concerning the Spiritual in Art*, there are sufficient art-historical references within the letters and enclosures to mark them out as an important new source for the study of Kandinsky's literary and artistic output at this critical stage in his development.[5]

Concerning the Spiritual in Art, originally published in German by Reinhard Piper in Munich in 1912, was one of only two full-length books that Kandinsky wrote (the other being *Point and Line to Plane* published in 1926).[6] The text had a long gestation period, Kandinsky often saying that it had taken him more than ten years to write. As the typescript in German is dated 'Murnau, 3 August 1909', it seems probable that the first notes and drafts were written sometime during 1898 and 1899.[7] Once the manuscript was complete it appears to have lain in Kandinsky's drawer for several years, as he could find no one to publish it. It was only through the persistence of Franz Marc, whom Kandinsky met in 1910, that Piper was finally persuaded to take the risk. Prior to its eventual publication, Kandinsky altered and amended the 1909 typescript quite considerably, adding, for instance, a completely new last chapter. This was not the first time, nor – as we shall see – the last, that amendments were made or suggested.[8] Although the book bore the date 1912, the first edition actually appeared in December 1911, in time for the Christmas market and published to coincide with the first *Blaue Reiter* exhibition.[9] The book sold out almost immediately and necessitated two further editions during the course of 1912.[10]

The genesis of the English translation, as with so many tales, does not begin with the main protagonists, but with another major figure in the British art scene, Frank Rutter, a founder member of the Allied Artists' Association (AAA).[11] It is intriguing that one of the few items of correspondence from Kandinsky in the Sadler archives written to people other than the Sadlers should be to Rutter.[12] Although the postcard – dated 22 August 1911 and written in French from Kandinsky's Munich address – comprises just seventeen lines, it contains a significant, if oblique, reference to work in progress:

> I am sending you 16 small texts, about which I wrote to you. There are still some which I don't have here at the moment.[13] At the end of the album will be printed 3 or 4 of my 'compositions for the stage'.[14] These are small 'tableaux' consisting of gesture (movement of 'dance'), colour (movement of painting) and of sound (musical movement – this will be done by the famous composer Hartmann);[15] on the principle of pure theatre.
> (SEE APPENDIX B, LETTER 1)

Significantly, it appears that Kandinsky was either still developing his contribution to the *Blaue Reiter* almanac or – more likely – considering an expanded version of his own *Klänge (Sounds)*. Although, he seems to have had the idea of combining these 'small texts' with the compositions for the stage, in the final version of *Sounds* only the former were published, while only one composition, *Yellow Sound*, appeared in the almanac. This latter stage piece resembles the description of the 'compositions' that Kandinsky outlines to Rutter in the card. The concept of diverse elements fusing into a greater entity was something Kandinsky seems to have reinterpreted from the idea of the 'total work of art', much discussed by Jugendstil poets and writers such as Stefan George. This idea was also something Kandinsky expounded in his essay 'On the Question of Form', which also appeared in *Der Blaue Reiter*. Thus, if the texts referred to are indeed prose poems for *Sounds*, Kandinsky would appear to have originally conceived of it as consisting of most of his recent poetic and 'theatrical' output. This makes more sense when one considers that Kandinsky's essay 'On Stage Composition', which he later published in Russian in the journal *Izobrazitel'noe Iskusstvo*, was originally intended as a pseudo-preface to *Yellow Sound*.[16] More significantly, the prose poems for *Sounds* seem in some way to be linked to his stage compositions, such as *Yellow Sound*. Indeed, the latter would appear to be an extension of, or rather a development from, these shorter prose poems.

Fortunately, Rutter's response to Kandinsky's card has survived.[17] Writing on behalf of the AAA, Rutter replies that he has sent the postcard and typed texts to 'Mr Sadler, who bought your prints' and encloses a cheque for £3.5.6 less commission and framing costs.[18] As Sadleir has indicated that he obtained Kandinsky's address from Rutter,[19] this postcard from the artist would appear to have been the source of that address. And so out of the blue, on 2 October 1911, Sadleir wrote to Kandinsky to say how delighted he was to have purchased some woodcuts and 'to ask whether you would mind if I reproduce one of them in my quarterly journal "Rhythm"'. To me this artistic revolution seems so important, that – with your permission – I would very much like to use such a woodcut', and he encloses a copy of the second issue of *Rhythm*.[20] On the 6 October 1911, Kandinsky replied:

Thank you for sending me your periodical. I am very glad to give permission for the reproduction of my woodcut.[21]

I am very pleased that the so-called modern art movement is mirrored in your journal and meets with interest in England. Mr Brooke from Cambridge also told me about this last winter.[22]

I enclose for you the prospectus of the art periodical that I have founded; the first issue is due to appear in January.[23]

Also this month my book 'Über das Geistige in der Kunst' will be published.[24] I will send you a copy. Please write back with your impression.

(SEE APPENDIX B, LETTER 2)

Thus, Sadleir learnt at an early stage about the recent publication of two of Kandinsky's most important textual works. Additionally, the prospectus for *Der Blaue Reiter* that

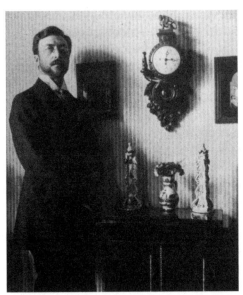

Kandinsky in Murnau, c.1914.

Kandinsky enclosed with the letter lists *Yellow Sound* and 'Construction in Painting' as due to appear in the first edition of the periodical.[25] In addition, Kandinsky may have forwarded to Sadleir (perhaps via Rutter) a preface to *Der Blaue Reiter*, as there is a typescript text, in French, in the Sadler archives.[26] Although *Sounds* (Kandinsky's third great publication of this era) is not mentioned in this letter, the artist specifically refers to the prose poems in his second letter to Sadleir, dated 7 December 1911:

> The texts have no connection with the woodcuts. I wrote them because I could not express these particular feelings by painting. There is however, as you will certainly have noticed yourself, a *deep* inner relationship between the texts and the woodcuts. And indeed even an outer one: I treat the word, the sentence in a very similar way to that in which I treat the line, the spot.
>
> The great inner relationship of all the arts is coming gradually ever more clearly to light. That is a great joy to me and I am happy that here too I can contribute somewhat.
>
> Read my texts without looking for an explicit narrative. Just let them work on your feeling, on your soul. And I think they will become clear to you. If this should really be the case, please write to me about it.
>
> (SEE APPENDIX B, LETTER 3)

Unfortunately, we do not know how Sadleir responded to these pieces;[27] we can only assume enthusiastically. It is doubtful, however, whether he realised the true significance of the typed texts in his possession. Two of the prose poems, for instance, were never published in German; 'Landscape' is known only in Russian,[28] and 'Evening' appears to be an undocumented and unpublished example. As an illustration of Kandinsky's intent, these

texts are quoted in full, and in English, in Appendix A. In these prose poems, Kandinsky's interest in the gulf between the sounds of words and their meaning is clearly evident, and as he mentions in his letter they work best on an unconscious level to induce a dream-like disorientation. In addition, Kandinsky's oft-used device of repeating words to separate them from their meanings was something that he discussed at greater length in *Concerning the Spiritual in Art*.[29] It is perhaps not surprising that the Dadaists adopted Kandinsky's poems with enthusiasm.[30] This merging of art forms to create 'monumental art', as he intimates to Sadleir, was an important element in Kandinsky's literary and artistic work at this time.

After this initial exchange of letters, Kandinsky and Sadleir seem not to have corresponded for another eight months.[31] It was not until Sadler proposed to his son that they should visit Munich in the late summer of 1912 that Sadleir took the opportunity to write to Kandinsky to see if they could make his acquaintance. Kandinsky replied on 13 August 1912 inviting them to spend the day with him and his close companion Gabriele Münter at their country cottage near Murnau, a small town about thirty-five miles south of Munich.[32] In his letter, Kandinsky discusses precise travel arrangements and apologises for not being in Munich, but mentions his serious illness (a hernia operation), which has prevented him from being able to travel. On 16 August 1912 the Sadlers spent an enjoyable day, by all accounts, engaging in animated conversation for over six hours.[33] In one of Sadler's letters to his wife from Germany, dated 17 August 1912, he describes the interior of the cottage and a little of Kandinsky's predilections:

> Everything was very simple. On the walls were small pictures on glass, very brightly coloured, of religious subjects mostly – some 18th century Bavarian peasant work, some painted by a man in Murnau, the latter practices the old traditional art, a few (mystic and primitive-looking) by Kandinsky himself. For Chinese art & character he has a deep respect & admiration. He was inclined (though not at all obtrusively) to talk about religious things, & is much interested in mystical books & the lives of the saints. He has had strange experiences of healing by faith.[34]

The trip cemented Kandinsky's friendship with the Sadlers. Indeed, they were among the first purchasers of Kandinsky's work in Britain and Sadler became the leading English champion of the artist, showing his work to guests who visited his home in Leeds.[35] Father and son's admiration for Kandinsky's work was greatly appreciated by the painter.[36] No doubt at this first and, as it turned out, only, face to face meeting, Sadleir and Kandinsky must have discussed possible publishing ventures for, within a month, he had secured the translation rights for *Concerning the Spiritual in Art* for a period of one year. Kandinsky set out the terms and conditions in a letter, sent soon after the Sadlers returned to England and added:

> One could *possibly* supplement the book in English with my article in the 'Blaue Reiter' about the question of form,[37] *if* the B. R. should not find a publisher.[38] Otherwise for the English version I would somewhat extend/expand the chapter 'Language of Form and Colour' – *perhaps* even fundamentally. I have had more thoughts on the subject this summer, although these naturally grew out of the earlier ones.[39] In this last case I would not sell for less than 1,000 marks.

In about 8 days I am going to Russia for 6–8 weeks.[40] If you reply after 10.x then please write to *Odessa* (South Russia), Skobelewstrasse 12, c/o Mr Kojevnikoff.

I have had a tour of my exhibition arranged.[41] I am sending you a catalogue, and also one to your father.

(SEE APPENDIX B, LETTER 5)

In Sadleir's reply of 2 December 1912, he mentions – as justification for a counter offer of 500 marks for the rights – the conservative nature of public taste for publications like *Concerning the Spiritual in Art* in England and the ignorance and slowness of many British librarians and booksellers in appreciating new ideas.[42] Partly swayed by Sadleir's arguments, Kandinsky replied on 8 December 1912, agreeing a final price of 500 marks, explaining that the wider circulation of his ideas overrode any financial considerations, and adding a postscript:

Perhaps (entirely *between ourselves!*) a largish exhibition of 'new' art will be going to America as soon as the spring of 1913, where I too will be represented.[43] That would be a good sales opportunity. *My* collection (which is now in Holland) is to be exhibited in London on April 13.[44] It would be splendid if the book could appear in English by then.

(SEE APPENDIX B, LETTER 6)

Unfortunately, Sadleir was unable to produce the publication in such a short time. Later that month, Kandinsky wrote to ask for Sadleir's publisher's address,[45] yet by 23 February 1913, he had still not heard anything:

Would you be so good as to let me know if and when you need the printing-plates and woodcut blocks for the translation of the 'Spiritual'. I am presently negotiating for a translation into Dutch.[46] So, maybe, I could order electrotypes for both translations at the same time. I shall be very grateful to you for the information. I am only now somewhat recovering since my Russian journey. I had to endure so many visits, all sorts of events that I scarcely managed even to work. Now, fortunately, it has become much quieter, and I am working with delight. There is after all nothing better than real work! I am immersing myself more and more in the secrets of the delicate balance, the veiled combinations, in the discrete co-existence of individual elements, which form that which is called a picture.[47]

(SEE APPENDIX B, LETTER 8)

Whilst negotiations about the translation were taking place, Sadler and Kandinsky continued to correspond. For instance, in late February 1913, Kandinsky replied to a letter from Sadler (now lost) referring to criticism he had recently received and a subsequent protest – on behalf of Kandinsky – by both members of the public and Herwarth Walden 'who has supported my art with such burning interest'.[48] As a measure of Walden's assistance, Kandinsky received a letter in March 1913 from Sadler who gave him the disappointing news that a proposal to hold the *Blaue Reiter* exhibition at the Goupil Gallery had fallen through:[49]

Herr Walden has written to me to ask for further suggestions and help. I need not say that I am delighted to give this and will do all in my power to help you and the organisers of the exhibition.

I have suggested the Alpine Club Gallery, Mill Street, Conduit Street, London W. This is one of the most beautiful little galleries in London. I am making inquiries about the cost for hiring the gallery and will write to Mr. Walden about it.[50]

By 9 April 1913, however, Kandinsky's thoughts returned to Sadleir and the book, informing him that he had been in touch with the German publisher Reinhard Piper to order the electrotypes directly from them to forward straight on to Sadleir. 'It is a nuisance to have to deal with him – one ruins one's nerves. I am very pleased that the translation is soon coming out and hope you liked 'Klänge' so far' (see Appendix B, letter 10). On the following day, 10 April 1913, Kandinsky wrote a long letter, as he had heard that Sadleir wished to change elements of the book. First, however, he thanks him for sending an unidentified publication, which he finds 'of great *theoretical* importance', and discusses developments in music, particularly the rejection of 'the tempered instrument (it would actually be more accurate to say the tempered scale). Russian musicians specifically are much occupied with this.[51] The result of this revolution can still not be guessed at all. But they will be wonderful'. He then writes at length and with care and consideration about the design and format of his book.

I have heard via Piper that you want to change the format of my book and therefore can't use our electrotypes. Is this change absolutely necessary? At the time, I chose with great love precisely this format, paper, typeface, etc. Editions 2 and 3 turned out completely as I wished (in the first edition the page [size] ('*mirror*' as it is called) is too big). Apart from purely artistic reasons, I chose the square format so that the reader is not forced to turn the book in order to see the reproductions properly. Apart from that, the book must not appear too thin. It is funny, but the reader is *absolutely* influenced by the *thickness* of the book. He shouldn't get the impression of a little brochure.

I just hope that the pictures will be flawless, don't you agree? You will surely also use all the woodcuts, which decorate the chapters (and the *title-page*). These are not drawings after all, but woodcuts directly printed from the wood-printing block, which I engraved. Electrotypes (but zinc blocks too) are just as good as these wood blocks.

You will surely also include the first and second *foreword* and the dedication to Elisabeth Tichieff. It would be quite the greatest delight for me if the English edition were to be *completely* the same as the 2nd or 3rd German edition. Are bound copies also being produced? These turned out very nicely with Piper. For advertising purposes a very good fact to use is that in Germany the book went through three editions in less than *one* year.

(SEE APPENDIX B, LETTER 11)

Kandinsky was well qualified to comment, as he was managing – as early as 1895 – a Moscow printing concern. He worked there for three years learning a great deal about the

relatively new technique of colour art reproductions. 'The printing of photographs fascinated him. This and the smell of printer's ink made him accustomed to the art of publication'.[52] As an indication of their increasingly close business and personal relationship, Kandinsky acknowledges an earlier missive that Sadleir had just sent him confirming the format of the book, before asking Sadleir's advice, in a note dated 25 April 1913, on whether to accept the AAA's invitation to exhibit, feeling that the whole expense of transport, fees and so on amounting to 100 marks might outweigh the slim chance of sales. He added: 'I would possibly decide in favour after all, but only in the event that *these* exhibitions are really seen and appreciated' (see Appendix B, letter 12). Whether or not a reply was received, Kandinsky went ahead,[53] and Sadleir commented in a later letter dated 24 July 1913 (not received by Kandinsky until 30 July) that 'he had visited the Albert Hall more than five times' to admire his paintings. Most of the rest of this letter concerns the price Piper wishes to charge for the 'electros'. More significantly, Sadleir is able to inform Kandinsky that 'the translation and the introduction are finished'.[54] On 25 July 1913, Kandinsky made one of his periodic requests from Sadleir for copies of articles, books, etc: 'Might I ask you to send the number of "Rhythm" with your article about my book and me to my Moscow publisher?[55] The address is Herr Angert, *Moscow*, Nikitsky Bulwar 7, kw. 5' (see Appendix B, letter 13).[56] A few days later, on 30 July 1913, Kandinsky replied to Sadleir's earlier letter of 24 July, which had now reached him. Kandinsky was still keen to find out who had bought the two works sent to the AAA exhibition:[57]

> 'Der Sturm' is publishing early in the autumn an album with *c*.60 of my pictures and 4 articles about me.[58] I would be happy to mention 2 in private ownership in London. I would also like to include the watercolour in your possession, with your name as owner.[59] Could you possibly send a photo (13 × 18) to 'Der Sturm', Ed. Herwarth Walden. I would be very much obliged to you! Please also forgive my haste: I am wearing myself out in Moscow.
> (SEE APPENDIX B, LETTER 14)

Finally, in early August 1913, the last piece of pre-publication business took place when Kandinsky notified Sadleir of the price of the 'electros' at a cost of 150 marks.[60] Yet, by 4 October 1913, whatever timetable there had been for the book's publication had gone seriously awry. Kandinsky had not heard anything from Sadleir since their correspondence in July and he had a number of important changes that he wished to make in the choice of illustrations, for a number of reasons:

> 1. The newly selected pictures are much more typical,
> 2. more varied and
> 3. are to be found in private ownership, which could have good practical consequences.
> I would exchange Impression 4 for *Impression* 2 (Koehler collection, Berlin), Improvisation 18 for *Impr.* 29 (A.J. Eddy collection, Chicago) and add a more recent picture of mine 'Small Joys' (Beffie collection, Amsterdam). So only Composition 2 would remain.[61]
> (SEE APPENDIX B, LETTER 16)

Unbeknownst to Kandinsky, Sadleir had travelled to New York to work for the publishing house Houghton, Mifflin and Company, and so towards the end of October 1913, Kandinsky was forced to write a letter to Sadleir's father asking for news, as 'I have had no reply to my urgent and important letter, and neither has Herr Angert, my Russian publisher, who has written to your son about the blocks of the "Spiritual".'[62] By the time Sadler had written back, Kandinsky had heard from Sadleir in Boston with news about the reproductions.[63] On 29 October Kandinsky informed Sadler that his son had made contact and that everything had been sorted out, so much so that he offers to dedicate a sketch or watercolour to him, adding: 'I cannot understand at all how pictures by me could get to Manchester.[64] But one experiences such surprises sometimes' (see Appendix B, letter 18). Sadler replied by return and Kandinsky wrote back on 10 November 1913 to confirm that he would select a suitable work:

not too large (I don't know if you have much hanging space!) but really good and characteristic of mine. I am working now on a large picture ('Composition 7') and have among the sketches a good thing which it is true is only a fragment of the large picture, nevertheless has an independent value. Something like that would, I think, be a good choice.[65]

It is a great joy to me to know that in you and your son, I know friends of my art in a distant country. And the number of my friends is by no means great.

(SEE APPENDIX B, LETTER 19)

On the same day, Kandinsky forwarded a letter to Sadleir in the USA to let him know that he had ordered the electrotypes, adding:

I am very curious about the English book. Presumably the publisher will also produce good advertising. And in America too? I know only two people there who are interested in my art: in New York Mr Alfred Stieglitz and Mr Arthur J. Eddy in Chicago. Both have new pictures by me, Mr Eddy indeed many and from nearly all my periods.[66] He himself is writing a book about the new art, which is appearing in the winter.[67] His picture collection is apparently very interesting.

(SEE APPENDIX B, LETTER 20)

On Christmas Eve 1913, Kandinsky wrote to Sadleir to thank him for forwarding an article and to give details of his publications in Russia:

I was very interested in the piece from the article in 'Camera Work'.[68] In Moscow a little book about me is being done by my publisher (portrait, small autobiography, some fairly long articles about me, list of owners and collections where my pictures are to be found and finally German, Dutch, English critiques for and against me) where probably (if it is not too late) the excerpt you sent will also be reprinted.[69] This little book has to introduce me to the general public in Russia, where I have rarely exhibited anything, and even then, not very much. I find this idea very inspired. The same publishing house has also undertaken the publication of the

'Spiritual' and the book, which just appeared in Berlin (1901–1913).[70] The 'Spiritual' I have enlarged somewhat and 'dotted the i's and crossed the t's' in many places. If therefore this book were to be published in America, I would very much like to include what I have done for the Russian edition.

(APPENDIX B, LETTER 21)

From the tone of the rest of the letter, Kandinsky must have assumed that the English translation of *Concerning the Spiritual in Art* had finally appeared in print, but Sadleir's reply of 8 January 1914 still left Kandinsky in the dark. After Sadleir thanks Kandinsky for forwarding the book published by *Der Sturm*, he apologises for not having found the time to locate photographs of his father's watercolours by Kandinsky for inclusion in the *Sturm* publication. He then goes on to inform Kandinsky that it would not be possible for the American edition of the *Spiritual* to include his corrections, as 'they have bought the same book as the one printed in England', and 'only the binding and the title page will be different'.[71] Later, on 14 January, Sadleir sent an urgent request for a photograph of Kandinsky to be used by both Houghton, Mifflin and Company for their publicity.[72] By the spring of 1914, however, Kandinsky realised something was amiss as he had still not received his fee nor heard anything from either the publishers or Sadleir, necessitating another letter, in April, to Sadler requesting assistance, as 'My finances don't look very pretty at the moment and this sum, though not large, would be *very* welcome to me.' He continues, 'Today I received the book by Arthur J. Eddy (Chicago) – 'Artists and Post-Impressionism', which at first sight seems interesting and well done. Many good reproductions (that is, the colour ones at the height of modern technique, which is not yet very advanced), comprehensive text, large bibliography, etc. Certainly it will make a strong impression in America and have the effect of surprise like a bomb' (see Appendix B, letter 22).[73] Coincidentally, on the same day, Sadleir wrote to Kandinsky finally enclosing a copy of the English version of *Concerning the Spiritual in Art*, with the news that a further fifteen copies had been sent separately, 'but the book will not be publicly available until 23 April and this example that I have personally sent is a special copy'.[74] So, twenty months after initial discussions about the translation, the published text finally arrived. There was still the American edition to take care of, but Sadleir could now take time off to get married. By the time Houghton, Mifflin and Company published the American version in June, there were a number of errors that necessitated Kandinsky writing a note of correction on 16 June 1914. He then goes on to bemoan his slender resources:

I would gladly now (even if unwillingly) dispose of the pictures, which I have now exhibited at the AAA for half the price, or still less.[75] Do you by any chance know anyone who would be interested in them? Mr Eddy (have you read his book?) obtained a commission in New York for me, which has helped me financially to some extent.[76] Nevertheless, I must keep looking! On the occasion of the great event in your life I have long wanted to ask your permission to send you a small picture by me. I have just now been able to pick out one of the sketches for the Americ[an] commission for this purpose.[77] I hope you will not turn it down. It is a constant

joy to me to know [that there are] such friends of my art in distant England as yourself and your father.
(SEE APPENDIX B, LETTER 23)

Sadleir's reply, with regard to the errors, was contrite: 'It seems that I have made some idiotic mistakes. I am greatly ashamed of my stupidity'.[78] To make amends, he promises to make enquiries about Kandinsky's works at the AAA exhibition and begs him not to send him anything as a gift that he could not otherwise sell. By 14 October 1914, with the outbreak of war, any further thoughts about the American edition had evaporated as Kandinsky wrote to Sadleir from Switzerland.[79] Part of this first letter, from Kandinsky and Münter in their temporary home in Goldach, is devoted to enlisting Sadleir's assistance in tracing the whereabouts of £100 sent to Kandinsky from Moscow via London, before he makes a comment about the war: 'What do you say about such a tragic time? How happy I would be if this battle were a spiritual battle and not [one] of guns. But the causes are deep seated. And so will the effects be also. Perhaps this bloody red line was necessary to divide what is to come, from the past' (see Appendix B, letter 24). However, in a letter to Sadler dated 8 November 1914 Kandinsky, with regard to his works in Sadler's collection, doubted

whether it was the war which inspired me in my drawings. I feel another battle much more important, of which this war is merely a material phase. This battle of which I am speaking is a struggle between two worlds – the age, almost ended, of the 19th century and that of the Future. I have been aware of this struggle for years. My hope is to reach an equilibrium of my soul, which will give me this possibility of creating positive harmony. Almost all my life I was seeking to give strong expression to this struggle, which I *understood* only a few years ago. What I would still like to attain is to place myself *above* the struggle and to find within myself definitive harmony. *Only* in this last case would I be able to find it in painting.
(SEE APPENDIX B, LETTER 25)

These words echo Marc's in *Der Blaue Reiter* when he wrote that 'we are standing today at the turning point of two long epochs, similar to the state of the world 1500 years ago, when there was also a transitional period without art and religion – a period in which great and traditional ideas died and new and unexpected ones took their place'.[80] Yet Kandinsky had also interpreted his age as one dominated by a struggle between the forces of good and evil, or between

the spiritual and the forces of evil, or materialism: Our epoch is a time of tragic collision between matter and spirit and of the downfall of the purely material world-view; for many, many people it is a time of a terrible, inescapable vacuum, a time of enormous questions; but for a few people it is a time of presentiment or of precognition of the path to Truth.[81]

In his writings after this point, Kandinsky clearly indicated that he saw abstraction as having the greatest potential for the expression of his anti-materialistic values. He also felt a stronger expression of his ideas could be achieved if the various arts were used to produce

contrasting effects rather than corresponding ones. For Kandinsky, the use of repetitious or corresponding stimuli was a nineteenth-century device and could not be as directly reflective of the conflict and disharmony that he felt were characteristic of his age. In *Concerning the Spiritual in Art*, Kandinsky describes the anxiety and fear of his age as similar to the 'sense of insecurity' of those 'dark clouds' when the shore begins to disappear from view at night.

It is interesting to conjecture what might have happened if the book had been published earlier than April 1914 and if Kandinsky's work had been exhibited more widely in Britain.[82] Interestingly, there were a number of key figures living in Britain and Paris before the First World War who were quick to realise the artist's importance and who were then able to act as conduits for his ideas and theories to reach a wider English-speaking audience. One of the first of these acolytes was a Canadian-born artist, conservator and teacher, Percyval Tudor-Hart.[83] During his student years in Paris in the 1890s, his closest friends were Léo Belmonte, Sándor Nagy and Aladár Körösfói-Kriesch.[84] The latter two founded an art school and an artist's colony at Gödöllő in Hungary in 1901, which seems to have been the inspiration for Tudor-Hart to open his own teaching establishment two years later at 69 Rue d'Assas, Montparnasse, Paris. It was founded, according to the prospectus he issued, 'to educate, in contradistinction to the mere teaching of formulae'. Students were encouraged to 'draw and paint without calculation, but with reason, and with the same natural precision and nicety that a child shows when throwing a stone.'[85] As we shall see, the school was to become a key venue for Kandinsky's ideas to be debated, enabling them to reach the USA and Britain at a crucial stage in the development of an avant-garde in both countries.

Two British artists who became aware of Kandinsky at an early stage were Wyndham Lewis and Edward Wadsworth. Although Lewis's studies in Munich took place during the first half of 1906 when Kandinsky lived in Paris, he would have known of Kandinsky's reputation in the Bavarian capital and is likely to have seen his work at the Salon d'Automne or among the Indépendents in Paris from 1905 onwards. Wadsworth, however, probably had a more concrete sense of the man: following his graduation from the Slade School of Art, he decided to further his studies in Munich from 1906 until Christmas 1907. Significantly, he stayed with family friends, Professor Wolpert and his daughter Else, in Schwabing, then the heart of Munich's thriving artist colony. In 1907 Kandinsky returned to Bavaria, following his nervous breakdown in Paris, and stayed in Murnau. By this time, Wadsworth was attending the Knirr Art School in Munich, located near the university at the rear of 29 Amalienstrasse, a mere four streets' distance from Kandinsky's home in the city.[86] The city at this pre-war time not only resounded to ideas emanating from Kandinsky, but also from his friend the poet Karl Wolfskehl and from personalities around the publishers of the German art magazine *Simplizissimus* and those that frequented the Café Luitpold in the city centre.

As we have seen, it was Frank Rutter who ensured that contact was made between the Sadlers and Kandinsky, thereby ensuring that *Concerning the Spiritual in Art* appeared in English two years after its publication in German. In fact, Rutter was the first British art critic to become conversant with Kandinsky's work, through the artist's participation in exhibitions of the Allied Artists Association. Although art critic of the *Sunday Times*, Rutter was keen to play a more active role in the British art scene. Rutter was in regular contact

with the Tate's Keeper (Director) D. S. MacColl, suggesting during this period that an exhibition could be organised in aid of the French Impressionist Fund or that artists could donate sketches that could be sold by auction. In tandem to this proselytising work, in 1908 Rutter decided to establish the AAA, with help from forty other founder members including Walter Sickert, Walter Bayes and other Camden Town Group artists as a platform for the work of progressive artists. Significantly, 1908 marked the opening of the Franco-British Exhibition celebrating the earlier signing of the Entente Cordiale between the two countries. This major Expo, which was held in White City, west London, attracted over eight million visitors and later served as the main venue for the Olympic Games. The initial exhibitions of the London Salon of the AAA were held at the Royal Albert Hall, with artists paying a small subscription fee that enabled them to exhibit up to a maximum of five (later reduced to three) works. From the outset, Rutter – as Secretary to the Committee of Management – was keen to include artists from abroad and, for the first show, enlisted the help of Princess Marie Tenecheff (a friend of Whistler) and Jan de Holewinski (1871–1927), who had been sent to London to organise an exhibition of Russian arts and crafts. For the inaugural exhibition, which opened on 11 July 1908, over eight hundred subscribers from the UK and the continental Europe exhibited more than 3,000 works, attracting considerable publicity, though not all of it favourable.[87] Rutter and his cohorts were not discouraged and Rutter remained closely involved in subsequent AAA exhibitions, inviting a throng of international artists to exhibit.[88]

One notable artist who exhibited at both the AAA and the Salon d'Automne exhibitions was the American-born Anne Estelle Rice. She arrived in Paris in 1906 and just two years later was exhibiting at the Salon. Although now known as a follower of Fauvism, she particularly admired the Cubists and the experiments of Kandinsky and Paul Klee. In her own work, however, she avoided symbolism and extreme abstraction, preferring to keep to what Cézanne called 'le motif'. Her importance in the story of the dissemination of Kandinsky's ideas lies in her circle of friends that began to coalesce in Montparnasse around 1910. They included Scottish Colourists J. D. Fergusson and S. J. Peploe, 'Dot' Banks (also known as Georges Banks), Jo Davidson the American sculptor, his wife Yvonne de Kerstatt, and editor and critic John Middleton Murray. Although Middleton Murray at this stage knew little about art, he had read with enthusiasm *Evolution creatrice* by the philosopher Henri Bergson and had studied Croce, whose *Estetica* appeared in 1909.[89] It was Middleton Murray who galvanised the group to contribute to a magazine that he hoped would proclaim the virtues of 'rhythm'. So began in the summer of 1911 the eponymous magazine, with Middleton Murray acting as editor and Fergusson as art editor, a post he retained almost to the end. *Rhythm* was initially published quarterly, then monthly, and encompassed art, music and literature with its aims and ideals outlined in a bold editorial for the first issue.

> Rhythm is a magazine with a purpose. Its title is the ideal of a new art, to which it will endeavour to give expression in England. We need an art that strikes deeper, that touches a profounder reality, that passes outside the bounds of a narrow aestheticism. Our intention is to provide art which shall have its roots below the surface, and be the rhythmical echo of the life with which it is in touch. 'What is exalted and tender in art is not made of feeble blood'.[90]

Not surprisingly, when the first German edition of van Gogh's correspondence was published in 1911, Middleton Murray and his friends on the magazine revelled in its epic single-mindedness; extracts in the Autumn 1911 issue of the periodical preceded others from non-English sources. Though published in London, Rhythm was essentially a sophisticated undergraduate magazine that brought in Murray's fellow Oxford contemporary, Michael Sadleir. Indeed, it was Sadleir who wrote the first article on art for the magazine, 'Fauvism and a Fauve', whilst Sadler senior enabled Rhythm to get off the ground by providing £50 for the printing costs. In his article on Fauvism, Sadleir celebrated the exhibition of Rice's work at the Baillie Gallery, London (April–May 1911). For Sadleir, Fauvism was the 'latest movement in painting'.[91] In the winter issue, Sadleir reaffirmed this view with a further article stressing the importance of Gauguin's legacy to Fauvism.[92] Other artists featured in the first year of production included Jessica Dismorr, Othon Friesz, J. D. Ferguson, S. J. Peploe, Paul Sérusier and André Derain.

This link with goings-on in Paris was crucial to the success of the magazine as more and more European and American artists flocked to what was fast becoming the main centre for avant-garde art. This period was also the apogee of Tudor-Hart's school, as students from around the world attended his lessons on colour theory. There were North American women from wealthy families, such Katharine McLennan and Catherine Rhodes (later to marry Tudor-Hart). Other American students included a precocious twelve year old, Richard Bassett, and more significantly Morgan Russell and Stanton Macdonald-Wright. As early as 1908 Russell had been introduced to Picasso, Rodin and Matisse by Leo and Gertrude Stein. By 1909 he had enrolled at the Académie Matisse, and by 1911 he was able to advance his interest in colour theory under Tudor-Hart. While attending classes Russell met Macdonald-Wright. They became firm friends, with colour theory and other aesthetic issues – no doubt including Kandinsky's recent work and ideas – acting as a common bond. Together they researched and developed a style that used colour to define form and meaning leading to abstractions they termed Synchromies in 1912, coinciding with the first appearance of Kandinsky's seminal text in German. Synchromism went on to have a profound impact on the American art world when works were first shown at the Armory Show in New York in 1913.[93] Another American, Marsden Hartley, though not at Tudor-Hart's school, also became aware of Kandinsky's new theories of painting when he moved to Paris in 1912, leading him to create his own abstractions. Back home, Georgia O'Keefe – then a young art student at the University of Virginia – was beginning to assimilate Kandinsky's theories through her teacher Arthur Wesley Dow's instruction. Meanwhile at Tudor-Hart's school, other artists who would later become more well known included the Kiwi Owen Merton (1887–1931) and the British artist James Wood, who was joined in 1913 by two London brothers from a distinguished painting family, Richard and Sydney Carline. Tudor-Hart was referred to by his students as 'the Darwin of colour'[94] and appears to have understood, at an early stage, the significance of Kandinsky's ideas. As Rose-Carol Washton Long has noted:

Although the idea of painting in an abstract style was not new, after 'Concerning the Spiritual in Art' reached the public, a number of artists such as Kupka, Mondrian, Delaunay, Picabia, Larionov and Goncharova began to exhibit works which contained few if any remnants of imagistic references in their colourful surfaces. A direct connection between Kandinsky and each of these artists cannot always be substantiated, but by 1912 critics across Europe had begun to view Kandinsky's paintings and essays as an example of one of the most radical trends in contemporary art.[95]

There is no doubt that for many artists *Concerning the Spiritual in Art* was the first major theoretical discussion of the problems of abstraction. Generally speaking, the continent warmed to Kandinsky's ideas and 'new art' quicker than Britain. Back in London, *Rhythm* had metamorphosed by June 1912 into a monthly periodical that reflected the 'succès de scandale' then emanating from the continent. Articles about the Ballets Russe begin to appear alongside illustrations by Picasso, Rousseau, Natalia Goncharova, Michel Larionov and the precocious newcomer Henri Gaudier-Brzeska. There was even a group exhibition of artists connected with *Rhythm* held at the Stafford gallery in November 1912. More importantly, this was also the year that short extracts from Kandinsky's *Concerning the Spiritual in Art* appeared in the magazine, translated by Michael Sadleir.[96]

With Kandinsky's theories appearing in an English publication for the first time, following the artist's yearly participation at the AAA exhibition, it was only a matter of time before the more perceptive of British painters began to incorporate Kandinsky's motifs and colour cadences in their own work. One of these artists was Spencer Gore, who during the late summer and autumn of 1912 painted over twenty canvases in Harold Gilman's house in the newly built Letchworth Garden City while the Gilmans were touring Scandinavia. Gore's works created here, with their geometrical forms and uniform colour groupings, reflect not only Kandinsky's works shown in the AAA, but also Gore's interest in paintings shown in other seminal exhibitions in London, such as *Manet and the Post-Impressionists* (1910–11), *Gauguin and Cézanne* at the Stafford Gallery, and *Italian Futurist Painters* at the Sackville Gallery in March 1911. It is interesting to note that Gore had radicalised his own colour palette as early as 1909 in Paris. One can, for example, detect Kandinskyesque flourishes in the sky of the *The Beanfield, Letchworth* 1912 (Tate). A friend of Gore's and another British artist, who acknowledged his debt to Kandinsky, and this time specifically to his theories, was C.R.W. Nevinson. Following his successful studies at the Slade in 1912, he began to move in Camden Town Group circles, notably with Sickert, Gilman and Percy Wyndham Lewis. Nevinson too followed the now well-worn path to Paris, furthering his education at the Académie Julian, the Salon des Indépendents, and in the 'Circle Russe' run by Matisse. Nicknamed 'Nevinski', he soon became friends with Modigliani and Severini, and apparently met such luminaries as Gertrude Stein, Lenin, Apollinaire, Derain, Boccioni, and no doubt bumped into Picasso for good measure. Following a visit home, he famously declared once back in Paris that he 'was dissatisfied with representational painting. Like many others I was attracted by abstract art, and the colour harmonies of Kandinsky.'[97] Travelling in the opposite direction, Tudor-Hart re-opened his influential school in Hampstead in 1913 with the Carline

brothers and Jas Wood continuing their studies.[98]

By early 1913, appreciation among the cognescenti for Kandinsky's ideas must have been sufficiently widespread for Georges Banks to publish a Kandinsky-like skit, 'The New Spirit in Art and Drama', in the January issue of *Rhythm*. This issue also contained a contribution by Rupert Brooke, 'The Night Journey'.[99] One of the more significant moments in bringing Kandinsky's work to the attention of a wider British public occurred somewhat atypically via the pen of Roger Fry. Fry had shown scant regard for modernist art in Paris whilst studying at the Académie Julian during the 1890s, and only later championed those avant-garde artists, such as Cézanne, Matisse, Picasso and Seurat, who retained representational elements within their work. By the time of the second Post-Impressionist Exhibition in 1912, Fry had arrived at a theoretical acceptance of abstract art. Kandinsky was a conundrum, however, that Fry was determined to solve. He overcame his hesitancy in one of his many insightful essays when reviewing the sixth annual AAA exhibition for the *Nation*.[100] He begins by contrasting Kandinsky's 'fascinating experiments into a new world of expressive form' with the cloying sentimentality of paintings belonging to the Victorian era, 'which by now [have] the faint and pleasant perfume of long forgotten, old-world things.' Similarly, he contrasts works by Brancusi and Epstein with Roman pastiches of Greek art and photographic realism of the nineteenth century. He then praises work by Wyndham Lewis, Therese Lessore, as well as Sickert's pupils Spencer Gore and Ethel Sands. But this is just a preamble to discussing 'the best pictures': three works by Kandinsky. One he refers to as a landscape while the other two are 'pure improvisations'. He suggests that one is on safer ground when viewing the landscape as it 'is easier to find one's way about in it'. He regards the forms and colours of the improvisations as having 'no possible justification except of rightness of their relations' and feels the pictures work by having 'the most definite and coherent expressive power' of all the paintings in the vast exhibition. Almost in passing Fry recognises that Kandinsky (alongside Picasso in his more recent works) has reached the stage where it is no longer necessary for representation 'to co-ordinate forms'.

> Although the landscape may be easier on the eye, the improvisations become more definite, more logical, and closely knit in structure, more surprisingly beautiful in their colour oppositions, more exact in their equilibrium. They are pure visual music, but I cannot any longer doubt the possibility of emotional expression by such abstract visual signs.

With that he goes on to discuss other notable works by Christian Krohg, Edward Wadsworth and Anne Estelle Rice in the exhibition. Because of the nature of this particular piece of journalism, Fry does not elaborate or analyse further, but the very fact that Kandinsky's pictures are marked as the most noteworthy elevates his status within the British art world. Strangely, Fry and the rest of the Bloomsbury group did not wholeheartedly embrace the creation of such abstract visual signs, notwithstanding one or two exceptions. In fact it was a couple of the artists mentioned in Fry's review who took up the challenge.

It cannot be a coincidence that Fry featured works by Lewis and Wadsworth in his review as they had recently begun working for the Omega Workshops that Fry had founded

as a limited company in July 1913.[101] Yet by October 1913, Lewis and Wadsworth had fallen out with Fry over commissions for an exhibition of a room of Omega Workshop designs at the Ideal Home Exhibition, London. With Fry's glowing endorsement of Kandinsky (above his two associates) in the article published in the *Nation* no doubt ringing in their ears, Lewis and Wadsworth became determined to form a rival group of artists, first as a co-operative workshop at the Rebel Art Centre and then as a fully fledged abstract group, which became known as the Vorticists. Lewis was the driving force behind Vorticism and by 20 June 1914 had galvanised his friends to provide copy for what would become the first issue of the magazine *Blast*, the mouthpiece of the movement. In addition to the manifestos and notes written by Lewis and illustrations of Vorticist paintings and designs, there were poems by Ezra Pound, stories by Ford Madox Hueffer and Rebecca West and, significantly, a review by Edward Wadsworth of Sadleir's translation of *Concerning the Spiritual in Art*. Back in February, Wadsworth had contacted Constable's, the publishers, to inform them that he intended to write a review. In a letter to Lewis at this time he comments that 'Sadler translates the title, *The Art of Spiritual Harmony*, which doesn't seem to me to what Kandinsky means at all'. Interestingly, he suggests, in the same letter, that 200 copies of their first issue of *Blast* should be distributed equally to Berlin, Dusseldorf and Hamburg. When the issue appeared, in addition to reviewing extracts from the book, which he titled 'Inner Necessity', Wadsworth also added his take on abstract art: 'He writes of art in its relation to the universe and the soul of man. He writes as an artist to whom form and colour are as much the vital and integral parts of the cosmic organisation as they are his means of expression'.[102] Indeed, a reproduction of Wadsworth's work *Radiation* appeared in the same issue, which already exhibits the influence of Kandinsky's work and ideas. 'Inner Necessity' opens with:

> This book is a most important contribution to the psychology of modern art. The author's eminence as an artist adds considerable value to the work – fine artists as a rule being extremely reluctant to, or incapable of, expressing their ideas in more than one medium. Herr Kandinsky, however, is a psychologist and a metaphysician of rare intuition and inspired enthusiasm.[103]

For Lewis, in a note entitled 'Orchestra of Media', it was Kandinsky's woodcuts and his 'original and bitter' use of colour combinations that ranked him above other avant-garde artists of the time, such as Matisse.[104] Mirroring the chaotic eddies of the vortex, Lewis appreciated Kandinsky's ideas about discordant colour harmonies suiting a more tumultuous epoch. There was also a close association, at this time, with Kandinsky's spiritual evolutionism evidenced in Lewis's interest in Feng Shui and the statement in *Blast* that 'In a painting certain forms MUST be SO'.[105] Line and colour were championed by Kandinsky and, for a time, Lewis allowed his creativity free reign to move around such elements at will. Yet, even in this first issue of *Blast* there were portents hinting at Lewis's future thinking in his statement, 'finest art is not pure Abstraction, nor is it unorganised life', a sentiment not far from Fry's published views. By the time of the second issue of *Blast*, published in 1915, Lewis was moving away from believing, like Kandinsky, that art could be a vehicle for transcendence. In his published text, 'Review of Contemporary Art', he states:

On the other hand, Kandinsky's spiritual values and musical analogies seem to be undesirable, even if feasible: just as, although believing in the existence of the supernatural, you may regard it as redundant and nothing to do with life. The art of painting, further, is for a living man, and the art most attached to life.[106]

Lewis does, however, admit that colours possess a 'poetry' of their own over and above their signifying function: '[My eyes] will never forget that red is the colour of blood, though it may besides that have a special property of exasperation'.[107] Although Kandinsky's new theories directed Lewis along a new path, it led him to a non-spiritual conclusion.

Tudor-Hart and his pupils were continuing to explore the boundaries of colour and spirituality. From Hilda Carline's extant paintings from this period, such as *A Fantasy* 1915 (Private Collection), one can see just how far Kandinsky's radical ideas about the psychical effects of form and colour had permeated Britain. Similarly, one sees references to Kandinsky's work in the paintings of other artists in Britain at this time. Even artists seemingly unsympathetic to Kandinsky display references to the master's theories. Mark Gertler, for instance, who found nothing of note in the regular AAA exhibitions, starts to incorporate – following a visit in 1915 to see Sir Michael Sadler's collection – Kandinskyesque motifs and detonative colour combinations in master works like *The Merry Go-Round* 1916 (Tate) and *Gilbert Cannan at his Mill Door* 1917 (Ashmolean, Oxford). It is James Wood, though, who appears to have absorbed the most from Tudor-Hart's teachings and his own reading of Kandinsky, more evident in work made after the First World War.[108] Wood was the chief instigator and co-author of *The Foundations of Aesthetics* with C. K. Ogden and I. A. Richards, which was first published in 1922.[109] Writing on the experience and enjoyment of art, Wood, Ogden and Richards studied the concept of synaesthesia, defining its expression in the visual arena as an awareness 'of certain shapes and colours. These when more closely studied usually reveal themselves as in three dimensions, or as artists say, in forms', and by studying these forms impulses are 'aroused and sustained, which gradually increase in variety and degree of systematisation'. Like Kandinsky, Wood and his co-authors assign emotions to colour effects: 'To these systems in their early stages will correspond the emotions such as joy, horror, melancholy, anger, and mirth; or attitudes such as love, veneration, sentimentality'.[110] Kandinsky believed that the psychological effects of colours were in fact the *vibrations of the soul* and Wood and his co-authors subscribed to a similar view, stating that:

> In the interpretation of works of art at an early stage, if we allow ourselves to take on the appropriate mood, we may come into contact with the personality of the artist [and that the choices that comprise an artwork seem] to be the only way, unless by telepathy, of coming into contact with other minds than our own.[111]

These views were mirrored in Wood's own paintings where the colour correspondences serve specific functions and where the work of art seems to vibrate and resonate beyond the canvas. Wood later developed his colour theories more fully and wrote, with the same co-authors, 'Colour Harmony', a manuscript that sadly never appeared in print.

One can see how Kandinsky's initial groundwork in *Concerning the Spiritual in Art* led to further discoveries in this area as well as leading to similar ground-breaking work in other fields during the 1920s, 1930s and 1940s. I. A. Richards, for instance, based his hugely influential literary theory – the notion of 'harmony' or balance of competing psychological impulses – on the principles of aesthetic reception mapped out in *The Foundations of Aesthetics*. Frank Rutter, meanwhile, had already written the introduction to the catalogue of the influential *Post-Impressionist and Futurist* exhibition at the Doré Galleries, London, in 1912, and in 1917 he collaborated with Herbert Read to co-found the radical journal *Arts and Letters*, which ran until 1920. In 1925, Rutter became involved with another new venture, the establishment of the Grosvenor School of Modern Art at 33 Warwick Square, London.[112] It seems likely that Rutter's lectures formed the basis for his book *Evolution in Modern Art: A Study of Modern Painting*, published in 1926. Here, in a chapter entitled, 'Futurism and Expressionism II', he favourably mentions some of Kandinsky's ideas:

> Kandinsky argued that painting, like music, should be able to give emotional pleasure without any appeal to association of material ideas. The contention is logical once we abandon representation as an indispensable element in picture-making.

Similarly, Herbert Read, in *The Meaning of Art* (1931), wrote: 'Of all types of modern painting, Kandinsky's comes nearest to a plastic equivalent for music.' Read was to inspire a new generation of artists in Britain to explore Kandinsky's work and writings, with Barbara Hepworth and Ben Nicholson visiting Paris in 1932. In the same year Edward Wadsworth was singled out in an article written by the curator of a group exhibition of contemporary English art in the Hamburg Kunsthalle as 'this independent and typically English artist who stands, without doubt across the Channel, for what Kandinsky does with us, and Léger in France.'[113] New artistic alliances were forming between Britain and the rest of Europe. In 1933 Hepworth and Nicholson, for instance, joined the Abstraction-Création group that included among its members Kandinsky, Sonia Delaunay, Jean Hélion, Auguste Herbin and Piet Mondrian. Myfanwy Evans (later to become the wife of the painter John Piper) travelled independently to Paris where she met Mondrian, Brancusi, Giacometti and Kandinsky. This experience prompted her and John Piper to start a journal devoted to abstract art in Britain that became known as *AXIS*.[114] Read wrote in his influential book, *Art Now*:

> There is a spiritual satisfaction in such [abstract] art which has nothing to do with the kind of emotional reaction to life which Rembrandt transmits; in Plato's words, it exists not relatively to anything else, but in its own proper nature, producing its own proper pleasures.[115]

By 1935, there was an increasing need in Britain for art to reflect the social and political upheavals taking place on the continent, making the approach in *AXIS* untenable. However, in 1936, a seminal touring exhibition, *Abstract and Concrete*, curated by Nicolette Gray, opened in Oxford seeing Nicholson participating alongside Arp, Gabo, Kandinsky and Mondrian.[116]

Michael Sadler and Michael Sadleir, London, c.1915

This show may have led Kandinsky to write the following passage in what would be his last letter to Sadler, on 22 October 1936:

> I am glad however that England is at least showing a lot of interest in new art – many exhibitions, always new galleries, periodicals, etc.
>
> I still remember very vividly my conversation with your son when he visited me with you. I asked him, on that occasion, whether there was any new art in England and whether the English public was at all interested in new art. He replied 'We English are slow; wait another 25 years and then there will be'. And then he added, 'We're slow but, on the other hand, not fickle; if we get interested in something then it's not over and done in an in instant, but very enduring.'
>
> As I now see, your son was completely right: after, in actual fact, 25 years, the interest in England has appeared and how! I believe you were one of the very first 'swallows' in this regard. But as they say, 'One swallow doesn't make a summer'. So this summer has taken rather a long time.
>
> (SEE APPENDIX B, LETTER 28)

Kandinsky could not have realised the full impact that a new group of artists in the United States, the Abstract Expressionists, would have in developing a form of abstract art that would communicate meaning and emotional content, expressing an inner artistic vision on a scale much larger than he could ever have envisaged. Since that time subsequent generations of artists have rediscovered *Concerning the Spiritual Art*, reinterpreting its tenets to ensure that its relevance is as strong today as it has always been; an endless summer indeed.

TRANSLATOR'S INTRODUCTION

IT is no common thing to find an artist who, even if he be willing to try, is capable of expressing his aims and ideals with any clearness and moderation. Some people will say that any such capacity is a flaw in the perfect artist, who should find his expression in line and colour, and leave the multitude to grope its way unaided towards comprehension. This attitude is a relic of the days when " l'art pour l'art " was the latest battle-cry; when eccentricity of manner and irregularity of life were more important than any talent to the would-be artist; when every one except oneself was bourgeois.

The last few years have in some measure removed this absurdity, by destroying the old convention that it was middle-class to be sane, and that between the artist and the outer-world yawned a gulf which few could cross. Modern artists are beginning to realize their social duties. They are the spiritual teachers of the world, and for their teaching to have weight, it must be comprehensible. Any attempt,

therefore, to bring artist and public into sympathy, to en-
able the latter to understand the ideals of the former, should
be thoroughly welcome; and such an attempt is this book
of Kandinsky's.

The author is one of the leaders of the new art move-
ment in Munich. The group of which he is a member
includes painters, poets, musicians, dramatists, critics, all
working to the same end—the expression of the *soul* of
nature and humanity, or, as Kandinsky terms it, the *innerer
Klang*.

Perhaps the fault of this book of theory—or rather the
characteristic most likely to give cause for attack—is the
tendency to verbosity. Philosophy, especially in the hands
of a writer of German, presents inexhaustible opportunities
for vague and grandiloquent language. Partly for this
reason, partly from incompetence, I have not primarily
attempted to deal with the philosophical basis of Kan-
dinsky's art. Some, probably, will find in this aspect
of the book its chief interest, but better service will be
done to the author's ideas by leaving them to the reader's
judgement than by even the most expert criticism.

The power of a book to excite argument is often the
best proof of its value, and my own experience has always
been that those new ideas are at once most challenging

and most stimulating which come direct from their author, with no intermediate discussion.

The task undertaken in this Introduction is a humbler but perhaps a more necessary one. England, throughout her history, has shown scant respect for sudden spasms of theory. Whether in politics, religion, or art, she demands an historical foundation for every belief, and when such a foundation is not forthcoming she may smile indulgently, but serious interest is immediately withdrawn. I am keenly anxious that Kandinsky's art should not suffer this fate. My personal belief in his sincerity and the future of his ideas will go for very little, but if it can be shown that he is a reasonable development of what we regard as serious art, that he is no adventurer striving for a momentary notoriety by the strangeness of his beliefs, then there is a chance that some people at least will give his art fair consideration, and that, of these people, a few will come to love it as, in my opinion, it deserves.

Post-Impressionism, that vague and much-abused term, is now almost a household word. That the name of the movement is better known than the names of its chief leaders is a sad misfortune, largely caused by the over-rapidity of its introduction into England. Within the space of two short years a mass of artists from Manet to the most

recent of all Cubists were thrust on a public, who had hardly realized Impressionism. The inevitable result has been complete mental chaos. The tradition of which true Post-Impressionism is the modern expression has been kept alive down the ages of European art by scattered and, until lately, neglected painters. But not since the time of the so-called Byzantines, not since the period of which Giotto and his School were the final splendid blossoming, has the "Symbolist" ideal in art held general sway over the " Naturalist." The Primitive Italians, like their predecessors the Primitive Greeks, and, in turn, their predecessors the Egyptians, sought to express the inner feeling rather than the outer reality.

This ideal tended to be lost to sight in the naturalistic revival of the renaissance, which derived its inspiration solely from those periods of Greek and Roman art which were pre-occupied with the expression of external reality. Although the all-embracing genius of Michael-Angelo kept the " Symbolist " tradition alive, it is the work of El Greco that merits the complete title of " Symbolist." From Greco springs Goya and the Spanish influence on Daumier and Manet. When it is remembered that, in the meantime, Rembrandt and his contemporaries, notably Brouwer, left their mark on French art in the work of

Delacroix, Decamps and Courbet, the way will be seen clearly open to Cézanne and Gauguin.

The phrase "symbolist tradition" is not used to express any conscious affinity between the various generations of artists. As Kandinsky says: "the relationships in art are not necessarily ones of outward form, but are founded on inner sympathy of meaning." Sometimes, perhaps frequently, a similarity of outward form will appear. But in tracing spiritual relationship only inner meaning must be taken into account.

There are, of course, many people who deny that Primitive Art had an inner meaning, or, rather, that what is called "archaic expression" was dictated by anything but ignorance of representative methods and defective materials. Such people are numbered among the bitterest opponents of Post-Impressionism, and indeed it is difficult to see how they could be otherwise. "Painting," they say, "which seeks to learn from an age when art was, however sincere, incompetent and uneducated, deliberately rejects the knowledge and skill of centuries." It will be no easy matter to conquer this assumption that Primitive art is merely untrained Naturalism, but until it is conquered there seems little hope for a sympathetic understanding of the symbolist ideal.

The task is all the more difficult because of the analogy drawn by friends of the new movement between the neo-primitive vision and that of a child. That the analogy contains a grain of truth does not make it the less mischievous. Freshness of vision the child has, and freshness of vision is an important element in the new movement. But beyond this a parallel is non-existent, must be non-existent in any art other than pure artificiality. It is one thing to ape ineptitude in technique and another to acquire simplicity of vision. Simplicity—or rather discrimination of vision—is the trade-mark of the true Post-Impressionist. He *observes* and then *selects* what is essential. The result is a logical and very sophisticated synthesis. Such a synthesis will find expression in simple and even harsh technique. But the process can only come *after* the naturalist process and not before it. The child has a direct vision, because his mind is unencumbered by association and because his power of concentration is unimpaired by a multiplicity of interests. His method of drawing is immature; its variations from the ordinary result from lack of capacity.

Two examples will make my meaning clearer. The child draws a landscape. His picture contains one or two objects only from the number before his eyes. These are the

objects which strike him as important. So far, good. But there is no relation between them; they stand isolated on his paper, mere lumpish shapes. The Post-Impressionist, however, selects his objects with a view to expressing by their means the whole feeling of the landscape. His choice falls on elements which sum up the whole, not those which first attract immediate attention.

Again, let us take the case of the definitely religious picture.[1] It is not often that children draw religious scenes. More often battles and pageants attract them. But since the revival of the religious picture is so noticeable a factor in the new movement, since the Byzantines painted almost entirely religious subjects, and finally, since a book of such drawings by a child of twelve has recently been published, I prefer to take them as my example. Daphne Allen's religious drawings have the graceful charm of childhood, but they are mere childish echoes of conventional prettiness. Her talent, when mature, will turn to the charming rather than to the vigorous. There could be no greater contrast between such drawing and that of—say—Cimabue. Cimabue's Madonnas are not pretty women, but huge, solemn sym-

[1] Religion, in the sense of awe, is present in all true art. But here I use the term in the narrower sense to mean pictures of which the subject is connected with Christian or other worship.

bols. Their heads droop stiffly; their tenderness is universal. In Gauguin's " Agony in the Garden " the figure of Christ is haggard with pain and grief. These artists have filled their pictures with a bitter experience which no child can possibly possess. I repeat, therefore, that the analogy between Post-Impressionism and child-art is a false analogy, and that for a trained man or woman to paint as a child paints is an impossibility.[1]

All this does not presume to say that the " symbolist " school of art is necessarily nobler than the " naturalist." I am making no comparison, only a distinction. When the difference in aim is fully realized, the Primitives can no longer be condemned as incompetent, nor the moderns as lunatics, for such a condemnation is made from a wrong point of view. Judgement must be passed, not on the failure to achieve " naturalism " but on the failure to express the inner meaning.

The brief historical survey attempted above ended with

[1] I am well aware that this statement is at variance with Kandinsky, who has contributed a long article—" Über die Formfrage "—to Der Blaue Reiter, in which he argues the parallel between Post-Impressionism and child vision, as exemplified in the work of Henri Rousseau. Certainly Rousseau's vision is childlike. He has had no artistic training and pretends to none. But I consider that his art suffers so greatly from his lack of training, that beyond a sentimental interest it has little to recommend it.

the names of Cézanne and Gauguin, and for the purposes of this Introduction, for the purpose, that is to say, of tracing the genealogy of the Cubists and of Kandinsky, these two names may be taken to represent the modern expression of the "symbolist" tradition.

The difference between them is subtle but goes very deep. For both, the ultimate and internal significance of what they painted counted for more than the significance which is momentary and external. Cézanne saw in a tree, a heap of apples, a human face, a group of bathing men or women, something more abiding than either photography or impressionist painting could present. He painted the "treeness" of the tree, as a modern critic has admirably expressed it. But in everything he did he showed the architectural mind of the true Frenchman. His landscape studies were based on a profound sense of the structure of rocks and hills, and, being structural, his art depends essentially on reality. Though he did not scruple, and rightly, to sacrifice accuracy of form to the inner need, the material of which his art was composed was drawn from the huge stores of actual nature.

Gauguin has greater solemnity and fire than Cézanne. His pictures are tragic or passionate poems. He also sacrifices conventional form to inner expression, but his

art tends ever towards the spiritual, towards that profounder emphasis which cannot be expressed in natural objects nor in words. True his abandonment of representative methods did not lead him to an abandonment of natural terms of expression—that is to say human figures, trees and animals do appear in his pictures. But that he was much nearer a complete rejection of representation than was Cézanne is shown by the course followed by their respective disciples.

The generation immediately subsequent to Cézanne, Herbin, Vlaminck, Friesz, Marquet, etc., do little more than exaggerate Cézanne's technique, until there appear the first signs of Cubism. These are seen very clearly in Herbin. Objects begin to be treated in flat planes. A round vase is represented by a series of planes set one into the other, which at a distance blend into a curve. This is the first stage.

The real plunge into Cubism was taken by Picasso, who, nurtured on Cézanne, carried to its perfectly logical conclusion the master's structural treatment of nature. Representation disappears. Starting from a single natural object, Picasso and the Cubists produce lines and project angles till their canvases are covered with intricate and often very beautiful series of balanced lines and curves.

They persist, however, in giving them picture titles which recall the natural object from which their minds first took flight.

With Gauguin the case is different. The generation of his disciples which followed him—I put it thus to distinguish them from his actual pupils at Pont Aven, Serusier and the rest—carried the tendency further. One hesitates to mention Derain, for his beginnings, full of vitality and promise, have given place to a dreary compromise with Cubism, without visible future, and above all without humour. But there is no better example of the development of synthetic symbolism than his first book of woodcuts.[1] Here is work which keeps the merest semblance of conventional form, which gives its effect by startling masses of black and white, by sudden curves, but more frequently by sudden angles.[2]

In the process of the gradual abandonment of natural

[1] " L'Enchanteur pourrissant," par Guillaume Apollinaire, avec illustrations gravées sur bois par André Derain. Paris, Kahnweiler, 1910.

[2] The renaissance of the angle in art is an interesting feature of the new movement. Not since Egyptian times has it been used with such noble effect. There is a painting of Gauguin's at Hagen, of a row of Tahitian women seated on a bench, that consists entirely of a telling design in Egyptian angles. Cubism is the result of this discovery of the angle, blended with the influence of Cézanne.

form, the "angle" school is paralleled by the "curve" school, which also descends wholly from Gauguin. The best known representative is Maurice Denis. But he has become a slave to sentimentality, and has been left behind. Matisse is the most prominent French artist who has followed Gauguin with curves. In Germany a group of young men, who form the Neue Künstlervereinigung in Munich, work almost entirely in sweeping curves, and have reduced natural objects purely to flowing, decorative units.

But while they have followed Gauguin's lead in abandoning representation both of these two groups of advance are lacking in spiritual meaning. Their aim becomes more and more decorative, with an undercurrent of suggestion of simplified form. Anyone who has studied Gauguin will be aware of the intense spiritual value of his work. The man is a preacher and a psychologist, universal by his very unorthodoxy, fundamental because he goes deeper than civilization. In his disciples this great element is wanting. Kandinsky has supplied the need. He is not only on the track of an art more purely spiritual than was conceived even by Gauguin, but he has achieved the final abandonment of all representative intention. In this way he combines in himself the spiritual and technical tendencies of one great branch of Post-Impressionism.

The question most generally asked about Kandinsky's art is: "What is he trying to do?" It is to be hoped that this book will do something towards answering the question. But it will not do everything. This—partly because it is impossible to put into words the whole of Kandinsky's ideal, partly because in his anxiety to state his case, to court criticism, the author has been tempted to formulate more than is wise. His analysis of colours and their effects on the spectator is not the real basis of his art, because, if it were, one could, with the help of a scientific manual, describe one's emotions before his pictures with perfect accuracy. And this is impossible.

Kandinsky is painting music. That is to say, he has broken down the barrier between music and painting, and has isolated the pure emotion, which, for want of a better name, we call the artistic emotion. Anyone who has listened to good music with any enjoyment will admit to an unmistakable but quite indefinable thrill. He will not be able, with sincerity, to say that such a passage gave him such visual impressions, or such a harmony roused in him such emotions. The effect of music is too subtle for words. And the same with this painting of Kandinsky's. Speaking for myself, to stand in front of some of his drawings or pictures gives a keener and more spiritual pleasure

than any other kind of painting. But I could not express in the least what gives the pleasure. Presumably the lines and colours have the same effect as harmony and rhythm in music have on the truly musical. That psychology comes in no one can deny. Many people—perhaps at present the very large majority of people—have their colour-music sense dormant. It has never been exercised. In the same way many people are unmusical—either wholly, by nature, or partly, for lack of experience. Even when Kandinsky's idea is universally understood there may be many who are not moved by his melody. For my part, something within me answered to Kandinsky's art the first time I met with it. There was no question of looking for representation; a harmony had been set up, and that was enough.

Of course colour-music is no new idea. That is to say attempts have been made to play compositions in colour, by flashes and harmonies.[1] Also music has been interpreted in colour. But I do not know of any previous attempt to paint, without any reference to music, compositions which shall have on the spectator an effect wholly divorced from representative association. Kandinsky refers to attempts to paint in colour-counterpoint. But that is a different matter,

[1] Cf. "Colour Music," by A. Wallace Rimington. Hutchinson. 6s. net.

in that it is the borrowing from one art by another of purely technical methods, without a previous impulse from spiritual sympathy.

One is faced then with the conflicting claims of Picasso and Kandinsky to the position of true leader of non-representative art. Picasso's admirers hail him, just as this Introduction hails Kandinsky, as a visual musician. The methods and ideas of each rival are so different that the title cannot be accorded to both. In his book, Kandinsky states his opinion of Cubism and its fatal weakness, and history goes to support his contention. The origin of Cubism in Cézanne, in a structural art that owes its very existence to matter, makes its claim to pure emotionalism seem untenable. Emotions are not composed of strata and conflicting pressures. Once abandon reality and the geometrical vision becomes abstract mathematics. It seems to me that Picasso shares a Futurist error when he endeavours to harmonize one item of reality—a number, a button, a few capital letters—with a surrounding aura of angular projections. There must be a conflict of impressions, which differ essentially in quality. One trend of modern music is towards realism of sound. Children cry, dogs bark, plates are broken. Picasso approaches the same goal from the opposite direction. It is as though he were

trying to work from realism to music. The waste of time is, to my mind, equally complete in both cases. The power of music to give expression without the help of representation is its noblest possession. No painting has ever had such a precious power. Kandinsky is striving to give it that power, and prove what is at least the logical analogy between colour and sound, between line and rhythm of beat. Picasso makes little use of colour, and confines himself only to one series of line effects—those caused by conflicting angles. So his aim is smaller and more limited than Kandinsky's even if it is as reasonable. But because it has not wholly abandoned realism but uses for the painting of feeling a structural vision dependent for its value on the association of reality, because in so doing it tries to make the best of two worlds, there seems little hope for it of redemption in either.

As has been said above, Picasso and Kandinsky make an interesting parallel, in that they have developed the art respectively of Cézanne and Gauguin, in a similar direction. On the decision of Picasso's failure or success rests the distinction between Cézanne and Gauguin, the realist and the symbolist, the painter of externals and the painter of religious feeling. Unless a spiritual value is accorded to Cézanne's work, unless he is believed to be a religious

painter (and religious painters need not paint Madonnas), unless in fact he is paralleled closely with Gauguin, his follower Picasso cannot claim to stand, with Kandinsky, as a prophet of an art of spiritual harmony.

If Kandinsky ever attains his ideal—for he is the first to admit that he has not yet reached his goal—if he ever succeeds in finding a common language of colour and line which shall stand alone as the language of sound and beat stands alone, without recourse to natural form or representation, he will on all hands be hailed as a great innovator, as a champion of the freedom of art. Until such time, it is the duty of those to whom his work has spoken, to bear their testimony. Otherwise he may be condemned as one who has invented a shorthand of his own, and who paints pictures which cannot be understood by those who have not the key of the cipher. In the meantime also it is important that his position should be recognized as a legitimate, almost inevitable outcome of Post-Impressionist tendencies. Such is the recognition this Introduction strives to secure.

MICHAEL T. H. SADLER.

REFERENCE

THOSE interested in the ideas and work of Kandinsky and his fellow artists would do well to consult:

DER BLAUE REITER, vol. i. Piper Verlag, München, 10 mk. This sumptuous volume contains articles by Kandinsky, Franz Marc, Arnold Schönberg, etc., together with some musical texts and numerous reproductions—some in colour—of the work of the primitive mosaicists, glass-painters, and sculptors, as well as of more modern artists from Greco to Kandinsky, Marc, and their friends. The choice of illustrations gives an admirable idea of the continuity and steady growth of the new painting, sculpture, and music.

KLÄNGE. By Wassily Kandinsky. Piper Verlag, München, 30 mk. A most beautifully produced book of prose-poems, with a large number of illustrations, many in colour. This is Kandinsky's most recent work.

Also the back and current numbers of *Der Sturm*, a weekly paper published in Berlin in the defence of the new art. Illustrations by Marc, Pechstein, le Fauconnier, Delaunay, Kandinsky, etc. Also poems and critical articles. Price per weekly number, 25 pfg. *Der Sturm* has in preparation an album of reproductions of pictures and drawings by Kandinsky.

For Cubism cf. Gleizes et Metzinger, "du Cubisme," and Guillaume Apollinaire, "Les Peintres Cubistes." Collection Les Arts. Paris, Figuière, per vol. 3 fr. 50 c.

DEDICATED TO THE MEMORY
OF ELISABETH TICHEJEFF

A
ABOUT GENERAL AESTHETIC

I. INTRODUCTION

EVERY work of art is the child of its age, and, in many cases, the mother of our emotions. It follows that each period of culture produces an art of its own which can never be repeated. Efforts to revive the art-principles of the past will at best produce an art that is still-born. It is impossible for us to live and feel, as did the ancient Greeks. In the same way those who strive to follow the Greek methods in sculpture achieve only a similarity of form, the work remaining soulless for all time. Such imitation is mere aping. Externally the

monkey completely resembles a human being; he will
sit holding a book in front of his nose, and turn over the
pages with a thoughtful aspect, but his actions have for
him no real meaning.

There is, however, in art another kind of external simi-
larity which is founded on a fundamental truth. When
there is a similarity of inner tendency in the whole moral
and spiritual atmosphere, a similarity of ideals, at first
closely pursued but later lost to sight, a similarity in
the inner feeling of any one period to that of another,
the logical result will be a revival of the external forms
which served to express those inner feelings in an earlier
age. An example of this to-day is our sympathy, our
spiritual relationship with the Primitives. Like ourselves,
these artists sought to express in their work only internal
truths, renouncing in consequence all consideration of
external form.

This all-important spark of inner life to-day is at present
only a spark. Our minds, which are even now only just
awakening after years of materialism, are infected with the
despair of unbelief, of lack of purpose and ideal. The
nightmare of materialism, which has turned the life of the
universe into an evil, useless game, is not yet past; it holds
the awakening soul still in its grip. Only a feeble light

Mosaic in S. Vitale, Ravenna

glimmers like a tiny star in a vast gulf of darkness. This feeble light is but a presentiment, and the soul, when it sees it, trembles in doubt whether the light is not a dream, and the gulf of darkness reality. This doubt, and the still harsh tyranny of the materialistic philosophy, divide our soul sharply from that of the Primitives. Our soul rings cracked when we seek to play upon it, as does a costly vase, long buried in the earth, which is found to have a flaw when it is dug up once more. For this reason, the Primitive phase, through which we are now passing, with its temporary similarity of form, can only be of short duration.

These two possible resemblances between the art forms of to-day and those of the past will be at once recognized as diametrically opposed to one another. The first, being purely external, has no future. The second, being internal, contains the seed of the future within itself. After the period of materialist effort, which held the soul in check until it was shaken off as evil, the soul is emerging, purged by trials and sufferings. Shapeless emotions such as fear, joy, grief, etc., which belonged to this time of effort, will no longer greatly attract the artist. He will endeavour to awake subtler emotions, as yet unnamed. Living himself a complicated and comparatively subtle life, his work will give to those observers

capable of feeling them lofty emotions beyond the reach
of words.

The observer of to-day, however, is seldom capable of
feeling such emotions. He seeks in a work of art a mere
imitation of nature which can serve some definite purpose
(for example a portrait in the ordinary sense) or a pre-
sentment of nature according to a certain convention
("impressionist" painting), or some inner feeling ex-
pressed in terms of natural form (as we say—a picture
with "stimmung"[1]). All those varieties of picture, when
they are really art, fulfil their purpose and feed the spirit.
Though this applies to the first case, it applies more
strongly to the third, where the spectator does feel a
corresponding thrill in himself. Such harmony or even
contrast of emotion cannot be superficial or worthless;
indeed the "stimmung" of a picture can deepen and
purify that of the spectator. Such works of art at least
preserve the soul from coarseness; they "key it up," so
to speak, to a certain height, as a tuning-key the strings
of a musical instrument. But purification, and extension

[1] "Stimmung" is almost untranslateable. It is almost "sentiment" in
the best sense, and almost "feeling." Many of Corot's twilight landscapes
are full of a beautiful "stimmung." Kandinsky uses the word later on
to mean the "essential spirit" of nature.—M. T. H. S.

in duration and size of this sympathy of soul, remain one-sided, and the possibilities of the influence of art are not exerted to their utmost.

* *
*

Imagine a building divided into many rooms. The building may be large or small. Every wall of every room is covered with pictures of various sizes; perhaps they number many thousands. They represent in colour bits of nature—animals in sunlight or shadow, drinking, standing in water, lying on the grass; near to, a Crucifixion by a painter who does not believe in Christ; flowers; human figures sitting, standing, walking; often they are naked; many naked women, seen foreshortened from behind; apples and silver dishes; portrait of Councillor So and So; sunset; lady in red; flying duck; portrait of Lady X; flying geese; lady in white; calves in shadow flecked with brilliant yellow sunlight; portrait of Prince Y; lady in green. All this is carefully printed in a book—name of artist—name of picture. People with these books in their hands go from wall to wall, turning over pages, reading the names. Then they go away, neither richer nor poorer than when they came, and are absorbed at

once in their business, which has nothing to do with art. Why did they come? In each picture is a whole lifetime imprisoned, a whole lifetime of fears, doubts, hopes, and joys.

Whither is this lifetime tending? What is the message of the competent artist? "To send light into the darkness of men's hearts—such is the duty of the artist," said Schumann. "An artist is a man who can draw and paint everything," said Tolstoi.

Of these two definitions of the artist's activity we must choose the second, if we think of the exhibition just described. On one canvas is a huddle of objects painted with varying degrees of skill, virtuosity and vigour, harshly or smoothly. To harmonize the whole is the task of art. With cold eyes and indifferent mind the spectators regard the work. Connoisseurs admire the "skill" (as one admires a tight-rope walker), enjoy the "quality of painting" (as one enjoys a pasty). But hungry souls go hungry away.

The vulgar herd stroll through the rooms and pronounce the pictures "nice" or "splendid." Those who could speak have said nothing, those who could hear have heard nothing. This condition of art is called "art for art's sake." This neglect of inner meanings, which is the

life of colours, this vain squandering of artistic power is called " art for art's sake."

The artist seeks for material reward for his dexterity, his power of vision and experience. His purpose becomes the satisfaction of vanity and greed. In place of the steady co-operation of artists is a scramble for good things. There are complaints of excessive competition, of over-production. Hatred, partisanship, cliques, jealousy, intrigues are the natural consequences of this aimless, materialist art.[1]

The onlooker turns away from the artist who has higher ideals and who cannot see his life purpose in an art without aims.

Sympathy is the education of the spectator from the point of view of the artist. It has been said above that art is the child of its age. Such an art can only create an artistic feeling which is already clearly felt. This art, which has no power for the future, which is only a child of the age and cannot become a mother of the future, is

[1] The few solitary exceptions do not destroy the truth of this sad and ominous picture, and even these exceptions are chiefly believers in the doctrine of art for art's sake. They serve, therefore, a higher ideal, but one which is ultimately a useless waste of their strength. External beauty is one element of a spiritual atmosphere. But beyond this positive fact (that what is beautiful is good) it has the weakness of a talent not used to the full. (The word talent is employed in the biblical sense.)

a barren art. She is transitory and to all intent dies the
moment the atmosphere alters which nourished her.

* *

*

The other art, that which is capable of educating further,
springs equally from contemporary feeling, but is at the
same time not only echo and mirror of it, but also has a
deep and powerful prophetic strength.

The spiritual life, to which art belongs and of which
she is one of the mightiest elements, is a complicated but
definite and easily definable movement forwards and up-
wards. This movement is the movement of experience.
It may take different forms, but it holds at bottom to the
same inner thought and purpose.

Veiled in obscurity are the causes of this need to move
ever upwards and forwards, by sweat of the brow, through
sufferings and fears. When one stage has been accom-
plished, and many evil stones cleared from the road, some
unseen and wicked hand scatters new obstacles in the
way, so that the path often seems blocked and totally
obliterated. But there never fails to come to the rescue
some human being, like ourselves in everything except
that he has in him a secret power of vision.

He sees and points the way. The power to do this he would sometimes fain lay aside, for it is a bitter cross to bear. But he cannot do so. Scorned and hated, he drags after him over the stones the heavy chariot of a divided humanity, ever forwards and upwards.

Often, many years after his body has vanished from the earth, men try by every means to recreate this body in marble, iron, bronze, or stone, on an enormous scale. As if there were any intrinsic value in the bodily existence of such divine martyrs and servants of humanity, who despised the flesh and lived only for the spirit! But at least such setting up of marble is a proof that a great number of men have reached the point where once the being they would now honour, stood alone.

II.
THE
MOVEMENT
OF THE
TRIANGLE

THE life of the spirit may be fairly represented in diagram as a large acute-angled triangle divided horizontally into unequal parts with the narrowest segment uppermost. The lower the segment the greater it is in breadth, depth, and area.

The whole triangle is moving slowly, almost invisibly forwards and upwards. Where the apex was to-day the second segment is to-morrow; what to-day can be understood only by the apex and to the rest of the triangle is an incomprehensible gibberish, forms to-morrow the true thought and feeling of the second segment.

At the apex of the top segment stands often one man,

and only one. His joyful vision cloaks a vast sorrow. Even those who are nearest to him in sympathy do not understand him. Angrily they abuse him as charlatan or madman. So in his lifetime stood Beethoven, solitary and insulted.[1] How many years will it be before a greater segment of the triangle reaches the spot where he once stood alone? Despite memorials and statues, are they really many who have risen to his level?[2]

In every segment of the triangle are artists. Each one of them who can see beyond the limits of his segment is a prophet to those about him, and helps the advance of the obstinate whole. But those who are blind, or those who retard the movement of the triangle for baser reasons, are fully understood by their fellows and acclaimed for their genius. The greater the segment (which is the same as saying the lower it lies in the triangle) so the greater the number who understand the words of the artist. Every segment hungers consciously or, much more often, unconsciously for their corresponding spiritual food. This

[1] Weber, composer of "Der Freischütz," said of Beethoven's VII Symphony: "The extravagances of genius have reached the limit; Beethoven is now ripe for an asylum." Of the opening phrase, on a reiterated "e," the Abbé Stadler said to his neighbour, when first he heard it: "Always that miserable 'e'; he seems to be deaf to it himself, the idiot!"

[2] Are not many monuments in themselves answers to that question?

food is offered by the artists, and for this food the segment immediately below will to-morrow be stretching out eager hands.

This simile of the triangle cannot be said to express every aspect of the spiritual life. For instance, there is never an absolute shadow-side to the picture, never a piece of unrelieved gloom. Even too often it happens that one level of spiritual food suffices for the nourishment of those who are already in a higher segment. But for them this food is poison; in small quantities it depresses their souls gradually into a lower segment; in large quantities it hurls them suddenly into the depths ever lower and lower. Sienkiewicz, in one of his novels, compares the spiritual life to swimming; for the man who does not strive tirelessly, who does not fight continually against sinking, will mentally and morally go under. In this strait a man's talent (again in the biblical sense) becomes a curse—and not only the talent of the artist, but also of those who eat this poisoned food. The artist uses his strength to flatter his lower needs; in an ostensibly artistic form he presents what is impure, draws the weaker elements to him, mixes them with evil, betrays men and helps them to betray themselves, while they convince themselves and others that they are spiritually thirsty,

and that from this pure spring they may quench their thirst. Such art does not help the forward movement, but hinders it, dragging back those who are striving to press onward, and spreading pestilence abroad.

Such periods, during which art has no noble champion, during which the true spiritual food is wanting, are periods of retrogression in the spiritual world. Ceaselessly souls fall from the higher to the lower segments of the triangle, and the whole seems motionless, or even to move down and backwards. Men attribute to these blind and dumb periods a special value, for they judge them by outward results, thinking only of material well-being. They hail some technical advance, which can help nothing but the body, as a great achievement. Real spiritual gains are at best undervalued, at worst entirely ignored.

The solitary visionaries are despised or regarded as abnormal and eccentric. Those who are not wrapped in lethargy and who feel vague longings for spiritual life and knowledge and progress, cry in harsh chorus, without any to comfort them. The night of the spirit falls more and more darkly. Deeper becomes the misery of these blind and terrified guides, and their followers, tormented and unnerved by fear and doubt, prefer to this gradual darkening the final sudden leap into the blackness.

At such a time art ministers to lower needs, and is used
for material ends. She seeks her sustenance in hard reali-
ties because she knows of nothing nobler. Objects, the
reproduction of which is considered her sole aim, remain
monotonously the same. The question "what?" disappears
from art; only the question "how?" remains. By what
method are these material objects to be reproduced? The
word becomes a creed. Art has lost her soul.

In the search for method the artist goes still further.
Art becomes so specialized as to be comprehensible only
to artists, and they complain bitterly of public indifference
to their work. For since the artist in such times has no
need to *say* much, but only to be notorious for some small
originality and consequently lauded by a small group of
patrons and connoisseurs (which incidentally is also a very
profitable business for him), there arise a crowd of gifted
and skilful painters, so easy does the conquest of art appear.
In each artistic circle are thousands of such artists, of whom
the majority seek only for some new technical manner, and
who produce millions of works of art without enthusiasm,
with cold hearts and souls asleep.

Competition arises. The wild battle for success becomes
more and more material. Small groups who have fought
their way to the top of the chaotic world of art and picture-

making entrench themselves in the territory they have won. The public, left far behind, looks on bewildered, loses interest and turns away.

* *

*

But despite all this confusion, this chaos, this wild hunt for notoriety, the spiritual triangle, slowly but surely, with irresistible strength, moves onwards and upwards.

The invisible Moses descends from the mountain and sees the dance round the golden calf. But he brings with him fresh stores of wisdom to man.

First by the artist is heard his voice, the voice that is inaudible to the crowd. Almost unknowingly the artist follows the call. Already in that very question " how? " lies a hidden seed of renaissance. For when this " how? " remains without any fruitful answer, there is always a possibility that the same " something " (which we call personality to-day) may be able to see in the objects about it not only what is purely material but also something less solid; something less " bodily " than was seen in the period of realism, when the universal aim was to reproduce anything " as it really is " and without fantastic imagination.[1]

[1] Frequent use is made here of the terms " material " and " non-material," and of the intermediate phrases " more " or " less material." Is everything

If the emotional power of the artist can overwhelm the "how?" and can give free scope to his finer feelings, then art is on the crest of the road by which she will not fail later on to find the "what" she has lost, the "what" which will show the way to the spiritual food of the newly-awakened spiritual life. This "what?" will no longer be the material, objective "what" of the former period, but the internal truth of art, the soul without which the body (*i.e.* the "how") can never be healthy, whether in an individual or in a whole people.

This "what" is the internal truth which only art can divine, which only art can express by those means of expression which are hers alone.

material? or is *everything* spiritual? Can the distinctions we make between matter and spirit be nothing but relative modifications of one or the other? Thought which, although a product of the spirit, can be defined with positive science, is matter, but of fine and not coarse substance. Is whatever cannot be touched with the hand, spiritual? The discussion lies beyond the scope of this little book; all that matters here is that the boundaries drawn should not be too definite.

III. SPIRITUAL REVOLUTION

THE spiritual triangle moves slowly onwards and up-
wards. To-day one of the largest of the lower seg-
ments has reached the point of using the first battle-cry of
the materialist creed. The dwellers in this segment group
themselves round various banners in religion. They call
themselves Jews, Catholics, Protestants, etc. But they are
really atheists, and this a few either of the boldest or the
narrowest openly avow. "Heaven is empty," "God is
dead." In politics these people are democrats and repub-
licans. The fear, horror and hatred which yesterday they
felt for these political creeds they now direct against anar-
chism, of which they know nothing but its much dreaded
name.

In economics these people are Socialists. They make

sharp the sword of justice with which to slay the hydra
of capitalism and to hew off the head of evil.

Because the inhabitants of this great segment of the
triangle have never solved any problem independently, but
are dragged as it were in a cart by those the noblest of
their fellow-men who have sacrificed themselves, they
know nothing of the vital impulse of life which they re-
gard always vaguely from a great distance. They rate this
impulse lightly, putting their trust in purposeless theory
and in the working of some logical method.

The men of the segment next below are dragged slowly
higher, blindly, by those just described. But they cling to
their old position, full of dread of the unknown and of
betrayal.

The higher segments are not only blind atheists but can
justify their godlessness with strange words; for example,
those of Virchow—so unworthy of a learned man—"I have
dissected many corpses, but never yet discovered a soul in
any one of them."

In politics they are generally republican, with a know-
ledge of different Parliamentary procedures; they read the
political leading articles in the newspapers. In economics
they are socialists of various grades, and can support their
" principles " with numerous quotations, passing from

Schweitzer's "Emma" via Lasalle's "Iron Law of Wages," to Marx's "Capital," and still further.

In these loftier segments other categories of ideas, absent in these just described, begin gradually to appear—science and art, to which last belong also literature and music.

In science these men are positivists, only recognizing those things that can be weighed and measured. Anything beyond that they consider as rather discreditable nonsense, that same nonsense about which they held yesterday the theories that to-day are proven.

In art they are naturalists, which means that they recognize and value the personality, individuality and temperament of the artist up to a certain definite point. This point has been fixed by others, and in it they believe unflinchingly.

<div align="center">* *</div>

<div align="center">*</div>

But despite their patent and well-ordered security, despite their infallible principles, there lurks in these higher segments a hidden fear, a nervous trembling, a sense of insecurity. And this is due to their upbringing. They know that the sages, statesmen and artists whom to-day they revere, were yesterday spurned as swindlers and charlatans. And the higher the segment in the triangle,

the better defined is this fear, this modern sense of in-security. Here and there are people with eyes which can see, minds which can correlate. They say to themselves: "If the science of the day before yesterday is rejected by the people of yesterday, and that of yesterday by us of to-day, is it not possible that what we call science now will be rejected by the men of to-morrow?" And the bravest of them answer "It is possible."

Then people appear who can distinguish those problems that the science of to-day has not yet explained. And they ask themselves: "Will science, if it continues on the road it has followed for so long, ever attain to the solution of these problems? And if it does so attain, will men be able to rely on its solution?" In these segments are also professional men of learning who can remember the time when facts now recognized by the Academies as firmly established, were scorned by those same Academies. There are also philosophers of aesthetic who write profound books about an art which was yesterday condemned as nonsense. In writing these books they remove the barriers over which art has most recently stepped and set up new ones which are to remain for ever in the places they have chosen. They do not notice that they are busy erecting barriers, not in front of art,

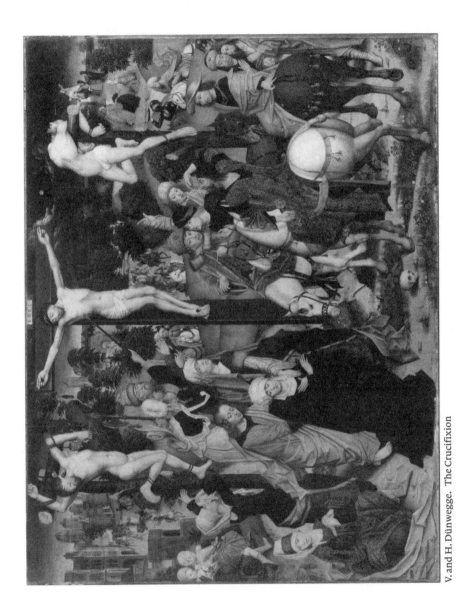

V. and H. Dünwegge. The Crucifixion

but behind it. And if they do notice this, on the morrow they merely write fresh books and hastily set their barriers a little further on. This performance will go on unaltered until it is realized that the most extreme prin-ciple of aesthetic can never be of value to the future, but only to the past. No such theory of principle can be laid down for those things which lie beyond, in the realm of the immaterial. That which has no material existence cannot be subjected to a material classification. That which belongs to the spirit of the future can only be realized in feeling, and to this feeling the talent of the artist is the only road. Theory is the lamp which sheds light on the petrified ideas of yesterday and of the more distant past.[1] And as we rise higher in the triangle we find that the uneasiness increases, as a city built on the most correct architectural plan may be shaken suddenly by the uncontrollable force of nature. Humanity is living in such a spiritual city, subject to these sudden disturbances for which neither architects nor mathe-maticians have made allowance. In one place lies a great wall crumbled to pieces like a card house, in another are the ruins of a huge tower which once stretched to heaven, built on many presumably immortal spiritual pillars.

[1] Cf. chap. vii.

The abandoned churchyard quakes and forgotten graves open and from them rise forgotten ghosts. Spots appear on the sun and the sun grows dark, and what theory can fight with darkness? And in this city live also men deafened by false wisdom who hear no crash, and blinded by false wisdom, so that they say "our sun will shine more brightly than ever and soon the last spots will disappear." But sometime even these men will hear and see.

But when we get still higher there is no longer this bewilderment. There work is going on which boldly attacks those pillars which men have set up. There we find other professional men of learning who test matter again and again, who tremble before no problem, and who finally cast doubt on that very matter which was yesterday the foundation of everything, so that the whole universe is shaken. Every day another scientific theory finds bold discoverers who overstep the boundaries of prophecy and, forgetful of themselves, join the other soldiers in the conquest of some new summit and in the hopeless attack on some stubborn fortress. But "there is no fortress that man cannot overcome."

* *

*

On the one hand, *facts* are being established which the science of yesterday dubbed swindles. Even newspapers, which are for the most part the most obsequious servants of worldly success and of the mob, and which trim their sails to every wind, find themselves compelled to modify their ironical judgements on the " marvels " of science and even to abandon them altogether. Various learned men, among them ultra-materialists, dedicate their strength to the scientific research of doubtful problems, which can no longer be lied about or passed over in silence.[1]

<p style="text-align:center">*　　*
*</p>

On the other hand, the number is increasing of those men who put no trust in the methods of materialistic science when it deals with those questions which have to do with " non-matter," or matter which is not accessible to our minds. Just as art is looking for help from the primitives, so these men are turning to half-forgotten

[1] Zöller, Wagner, Butleroff (Petersburg), Crookes (London), etc. ; later on, C. H. Richet, C. Flammarion. The Parisian paper " Le Matin," published about two years ago the discoveries of the two last named under the title " Je le constate, mais je ne l'explique pas." Finally there are C. Lombroso, the inventor of the anthropological method of diagnosing crime, and Eusapio Palladino.

times in order to get help from their half-forgotten methods. However, these very methods are still alive and in use among nations whom we, from the height of our knowledge, have been accustomed to regard with pity and scorn. To such nations belong the Indians, who from time to time confront those learned in our civilization with problems which we have either passed by unnoticed or brushed aside with superficial words and explanations.[1] Frau Blavatzky was the first person, after a life of many years in India, to see a connection between these "savages" and our "civilization." From that moment there began a tremendous spiritual movement which to-day includes a large number of people and has even assumed a material form in the *Theosophical Society*. This society consists of groups who seek to approach the problem of the spirit by way of the *inner* knowledge. The theory of Theosophy which serves as the basis to this movement was set out by Blavatzky in the form of a catechism in which the pupil receives definite answers to his questions from the theosophical point of view.[2]

[1] Frequently in such cases use is made of the word hypnotism; that same hypnotism which, in its earlier form of mesmerism, was disdainfully put aside by various learned bodies.

[2] H. P. Blavatzky, "The Key of Theosophy," London, 1889.

Theosophy, according to Blavatzky, is synonymous with *eternal truth*. "The new torch-bearer of truth will find the minds of men prepared for his message, a language ready for him in which to clothe the new truths he brings, an organization awaiting his arrival, which will remove the merely mechanical, material obstacles and difficulties from his path." And then Blavatzky continues: "The earth will be a heaven in the twenty-first century in comparison with what it is now," and with these words ends her book.

* *

*

When religion, science and morality are shaken, the two last by the strong hand of Nietzsche, and when the outer supports threaten to fall, man turns his gaze from externals in on to himself. Literature, music and art are the first and most sensitive spheres in which this spiritual revolution makes itself felt. They reflect the dark picture of the present time and show the importance of what at first was only a little point of light noticed by few and for the great majority non-existent. Perhaps they even grow dark in their turn, but on the other hand they turn away from the soulless life of the present towards those substances and

ideas which give free scope to the non-material strivings of the soul.

A poet of this kind in the realm of literature is Maeterlinck. He takes us into a world which, rightly or wrongly, we term supernatural. La Princesse Maleine, Les Sept Princesses, Les Aveugles, etc., are not people of past times as are the heroes in Shakespeare. They are merely souls lost in the clouds, threatened by them with death, eternally menaced by some invisible and sombre power.

Spiritual darkness, the insecurity of ignorance and fear pervade the world in which they move. Maeterlinck is perhaps one of the first prophets, one of the first artistic reformers and seers to herald the end of the decadence just described. The gloom of the spiritual atmosphere, the terrible, but all-guiding hand, the sense of utter fear, the feeling of having strayed from the path, the confusion among the guides, all these are clearly felt in his works.[1]

This atmosphere Maeterlinck creates principally by purely artistic means. His material machinery (gloomy

[1] To the front rank of such seers of the decadence belongs also Alfred Kubin. With irresistible force both Kubin's drawings and also his novel "Die Andere Seite" seem to engulf us in the terrible atmosphere of empty desolation.

mountains, moonlight, marshes, wind, the cries of owls, etc.) plays really a symbolic rôle and helps to give the inner note.[1] Maeterlinck's principal technical weapon is his use of words. The word may express an inner harmony. This inner harmony springs partly, perhaps principally, from the object which it names. But if the object is not itself seen, but only its name heard, the *mind* of the hearer receives an abstract impression only, that is to say as of the object dematerialized, and a corresponding vibration is immediately set up in the *heart*.

The apt use of a word (in its poetical meaning), repetition of this word, twice, three times or even more frequently, according to the need of the poem, will not only tend to intensify the inner harmony but also bring to light unsuspected spiritual properties of the word itself. Further

[1] When one of Maeterlinck's plays was produced in St. Petersburg under his own guidance, he himself at one of the rehearsals had a tower represented by a plain piece of hanging linen. It was of no importance to him to have elaborate scenery prepared. He did as children, the greatest imaginers of all time, always do in their games; for they use a stick for a horse or create entire regiments of cavalry out of chalks. And in the same way a chalk with a notch in it is changed from a knight into a horse. On similar lines the imagination of the spectator plays in the modern theatre, and especially in that of Russia, an important part. And this is a notable element in the transition from the material to the spiritual in the theatre of the future.

than that, frequent repetition of a word (again a favourite
game of children, which is forgotten in after life) deprives
the word of its original external meaning. Similarly, in
drawing, the abstract message of the object drawn tends to
be forgotten and its meaning lost. Sometimes perhaps we
unconsciously hear this real harmony sounding together
with the material or later on with the non-material sense
of the object. But in the latter case the true harmony
exercises a direct impression on the soul. The soul under-
goes an emotion which has no relation to any definite
object, an emotion more complicated, I might say more
super-sensuous than the emotion caused by the sound of a
bell or of a stringed instrument. This line of development
offers great possibilities to the literature of the future. In
an embryonic form this word—power—has already been
used in "Serres Chaudes."[1] As Maeterlinck uses them,
words which seem at first to create only a neutral im-
pression have really a more subtle value. Even a familiar
word like "hair," if used in a certain way can intensify
an atmosphere of sorrow or despair. And this is Maeter-
linck's method. He shows that thunder, lightning and a
moon behind driving clouds, in themselves material means,

[1] " Serres Chaudes, suivies de Quinze Chansons," par Maurice Maeter-
linck. Bruxelles. Lacomblez. 2 f. 50 c.

can be used in the theatre to create a greater sense of terror than they do in nature.

The true inner forces do not lose their strength and effect so easily.[1] And the word which has two meanings, the first direct, the second indirect, is the pure material of poetry and of literature, the material which these arts alone can manipulate and through which they speak to the spirit.

Something similar may be noticed in the music of Wagner. His famous *leit motiv* is an attempt to give personality to his characters by something beyond theatrical expedients and light effect. His method of using a definite *motiv* is a purely musical method. It creates a spiritual atmosphere by means of a musical phrase which precedes the hero, which he seems to radiate forth from any distance.[2] The most modern musicians like Debussy create a spiritual impression, often taken from nature, but embodied in purely musical form. For this reason Debussy is often classed with the impressionist painters on the

[1] A comparison between the work of Poe and Maeterlinck shows the course of artistic transition from the material to the abstract.

[2] Frequent attempts have shown that such a spiritual atmosphere can belong not only to heroes but to any human being. Sensitives cannot, for example, remain in a room in which a person has been who is spiritually antagonistic to them, even though they know nothing of his existence.

ground that he resembles these painters in using natural phenomena for the purposes of his art. Whatever truth there may be in this comparison merely accentuates the fact that the various arts of to-day learn from each other and often resemble each other. But it would be rash to say that this definition is an exhaustive statement of Debussy's significance. Despite his similarity with the impressionists this musician is deeply concerned with spiritual harmony, for in his works one hears the suffering and tortured nerves of the present time. And further Debussy never uses the wholly material note so characteristic of programme music, but trusts mainly in the creation of a more abstract impression.

Debussy has had a great influence on Russian music, notably on Mussorgsky. So it is not surprising that he stands in close relation to the young Russian composers, the chief of whom is Skrjabin. The experience of the hearer is frequently the same during the performance of the works of these two musicians. He is often snatched quite suddenly from a series of modern discords into the charm of more or less conventional beauty. He feels himself often insulted, tossed about like a tennis ball over the net between the two parties of the outer and the inner beauty. To those who are not accustomed to it the inner

beauty appears as ugliness because humanity in general inclines to the outer and knows nothing of the inner. Almost alone in severing himself from conventional beauty is the Austrian composer, Arnold Schönberg. He says in his "Harmonielehre": "Every combination of notes, every advance is possible, but I am beginning to feel that there are also definite rules and conditions which incline me to the use of this or that dissonance."[1]

This means that Schönberg realizes that the greatest freedom of all, the freedom of an unfettered art, can never be absolute. Every age achieves a certain measure of this freedom, but beyond the boundaries of its freedom the mightiest genius can never go. But the measure of freedom of each age must be constantly enlarged. Schönberg is endeavouring to make complete use of his freedom and has already discovered gold mines of new beauty in his search for spiritual harmony. His music leads us into a realm where musical experience is a matter not of the ear but of the soul alone—and from this point begins the music of the future.

A parallel course has been followed by the impressionist movement in painting. It is seen in its dogmatic and

[1] "Die Musik," p. 104, from the "Harmonielehre" (Verlag der Universal Edition).

most naturalistic form in so-called Neo-Impressionism.
The theory of this is to put on the canvas the whole
glitter and brilliance of nature, and not only an isolated
aspect of her.

It is interesting to notice three practically contemporary
and totally different groups in painting. They are (1)
Rossetti and his pupil Burne-Jones, with their followers;
(2) Böcklin and his school; (3) Segantini, with his un-
worthy following of photographic artists.

I have chosen these three groups to illustrate the search
for the abstract in art. Rossetti sought to revive the non-
materialism of the pre-Raphaelites. Böcklin busied him-
self with mythological scenes, but was in contrast to
Rossetti in that he gave strongly material form to his
legendary figures. Segantini, outwardly the most material
of the three, selected the most ordinary objects (hills,
stones, cattle, etc.) often painting them with the minutest
realism, but he never failed to create a spiritual as well as
a material value, so that really he is the most non-material
of the trio.

These men sought for the " inner " by way of the
" outer."

By another road, and one more purely artistic, the great
seeker after a new sense of form approached the same

Dürer. The Descent from the Cross

problem. Cézanne made a living thing out of a teacup, or rather in a teacup he realized the existence of something alive. He raised still life to such a point that it ceased to be inanimate.

He painted these things as he painted human beings, because he was endowed with the gift of divining the inner life in everything. His colour and form are alike suitable to the spiritual harmony. A man, a tree, an apple, all were used by Cézanne in the creation of something that is called a "picture," and which is a piece of true inward and artistic harmony. The same intention actuates the work of one of the greatest of the young Frenchmen, Henri Matisse. He paints "pictures," and in these "pictures" endeavours to reproduce the divine.[1] To attain this end he requires as a starting point nothing but the object to be painted (human being or whatever it may be), and then the methods that belong to painting alone, colour and form.

By personal inclination, because he is French and because he is specially gifted as a colourist, Matisse is apt to lay too much stress on the colour. Like Debussy, he cannot always refrain from conventional beauty; Impressionism is in his blood. One sees pictures of Matisse

[1] Cf. his article in "Kunst und Künstler," 1909, No. 8.

which are full of great inward vitality, produced by the stress of the inner need, and also pictures which possess only outer charm, because they were painted on an outer impulse. (How often one is reminded of Manet in this.) His work seems to be typical French painting, with its dainty sense of melody, raised from time to time to the summit of a great hill above the clouds.

But in the work of another great artist in Paris, the Spaniard Pablo Picasso, there is never any suspicion of this conventional beauty. Tossed hither and thither by the need for self-expression, Picasso hurries from one manner to another. At times a great gulf appears between consecutive manners, because Picasso leaps boldly and is found continually by his bewildered crowd of followers standing at a point very different from that at which they saw him last. No sooner do they think that they have reached him again than he has changed once more. In this way there arose Cubism, the latest of the French movements, which is treated in detail in Part II. Picasso is trying to arrive at constructiveness by way of proportion. In his latest works (1911) he has achieved the logical destruction of matter, not, however, by dissolution but rather by a kind of a parcelling out of its various divisions and a constructive scattering of these divisions about the canvas.

But he seems in this most recent work distinctly desirous of keeping an appearance of matter. He shrinks from no innovation, and if colour seems likely to balk him in his search for a pure artistic form, he throws it overboard and paints a picture in brown and white; and the problem of purely artistic form is the real problem of his life.

In their pursuit of the same supreme end Matisse and Picasso stand side by side, Matisse representing colour and Picasso form.

IV.

THE

PYRAMID

A ND so at different points along the road are the
different arts, saying what they are best able to
say, and in the anguage which is peculiarly their own.
Despite, or perhaps thanks to, the differences between
them, there has never been a time when the arts approached
each other more nearly than they do to-day, in this later
phase of spiritual development.

In each manifestation is the seed of a striving towards
the abstract, the non-material. Consciously or un-
consciously they are obeying Socrates' command—Know
thyself. Consciously or unconsciously artists are studying
and proving their material, setting in the balance the

spiritual value of those elements, with which it is their several privilege to work.

And the natural result of this striving is that the various arts are drawing together. They are finding in Music the best teacher. With few exceptions music has been for some centuries the art which has devoted itself not to the reproduction of natural phenomena, but rather to the expression of the artist's soul, in musical sound.

A painter, who finds no satisfaction in mere representation, however artistic, in his longing to express his inner life, cannot but envy the ease with which music, the most non-material of the arts to-day, achieves this end. He naturally seeks to apply the methods of music to his own art. And from this results that modern desire for rhythm in painting, for mathematical, abstract construction, for repeated notes of colour, for setting colour in motion.

This borrowing of method by one art from another, can only be truly successful when the application of the borrowed methods is not superficial but fundamental. One art must learn first how another uses its methods, so that the methods may afterwards be applied to the borrower's art from the beginning, and suitably. The artist must not forget that in him lies the power of true

application of every method, but that that power must be developed.

In manipulation of form music can achieve results which are beyond the reach of painting. On the other hand, painting is ahead of music in several particulars. Music, for example, has at its disposal duration of time; while painting can present to the spectator the whole content of its message at one moment.[1] Music, which is outwardly unfettered by nature, needs no definite form for its expression.[2] Painting to-day is almost exclusively concerned with the reproduction of natural forms and phenomena. Her business is now to test her strength and methods, to know herself as music has done

[1] These statements of difference are, of course, relative; for music can on occasions dispense with extension of time, and painting make use of it.

[2] How miserably music fails when attempting to express material appearances is proved by the affected absurdity of programme music. Quite lately such experiments have been made. The imitation in sound of croaking frogs, of farmyard noises, of household duties, makes an excellent music hall turn and is amusing enough. But in serious music such attempts are merely warnings against any imitation of nature. Nature has her own language, and a powerful one; this language cannot be imitated. The sound of a farmyard in music is never successfully reproduced, and is unnecessary waste of time. The "stimmung" of nature can be imparted by every art, not, however, by imitation, but by the artistic divination of its inner spirit.

for a long time, and then to use her powers to a truly artistic end.

And so the arts are encroaching one upon another, and from a proper use of this encroachment will rise the art that is truly monumental. Every man who steeps himself in the spiritual possibilities of his art is a valuable helper in the building of the spiritual pyramid which will some day reach to heaven.

B
ABOUT PAINTING

V. THE PSYCHOLOGICAL WORKING
OF COLOUR

TO let the eye stray over a palette, splashed with many colours, produces a dual result. In the first place one receives *a purely physical impression*, one of pleasure and contentment at the varied and beautiful colours. The eye is either warmed or else soothed and cooled. But these physical sensations can only be of short duration. They are merely superficial and leave no lasting impression, for the soul is unaffected. But although the effect of the colours is forgotten when the eye is turned away, the superficial impression of varied colour may be the starting point of a whole chain of related sensations.

On the average man only the impressions caused by very

familiar objects, will be purely superficial. A first encounter
with any new phenomenon exercises immediately an im-
pression on the soul. This is the experience of the child
discovering the world, to whom every object is new. He
sees a light, wishes to take hold of it, burns his finger and
feels henceforward a proper respect for flame. But later
he learns that light has a friendly as well as an unfriendly
side, that it drives away the darkness, makes the day longer,
is essential to warmth, cooking, play-acting. From the mass
of these discoveries is composed a knowledge of light,
which is indelibly fixed in his mind. The strong, intensive
interest disappears and the various properties of flame are
balanced against each other. In this way the whole world
becomes gradually disenchanted. It is realized that trees
give shade, that horses run fast and motor-cars still faster,
that dogs bite, that the figure seen in a mirror is not a real
human being.

As the man develops, the circle of these experiences
caused by different beings and objects, grows ever wider.
They acquire an inner meaning and eventually a spiritual
harmony. It is the same with colour, which makes only
a momentary and superficial impression on a soul but
slightly developed in sensitiveness. But even this superficial
impression varies in quality. The eye is strongly attracted

by light, clear colours, and still more strongly attracted by those colours which are warm as well as clear; vermilion has the charm of flame, which has always attracted human beings. Keen lemon-yellow hurts the eye in time as a prolonged and shrill trumpet-note the ear, and the gazer turns away to seek relief in blue or green.

But to a more sensitive soul the effect of colours is deeper and intensely moving. And so we come to the second main result of looking at colours: *their psychic effect.* They produce a corresponding spiritual vibration, and it is only as a step towards this spiritual vibration that the elementary physical impression is of importance.

Whether the psychic effect of colour is a direct one, as these last few lines imply, or whether it is the outcome of association, is perhaps open to question. The soul being one with the body, the former may well experience a psychic shock, caused by association acting on the latter. For example, red may cause a sensation analogous to that caused by flame, because red is the colour of flame. A warm red will prove exciting, another shade of red will cause pain or disgust through association with running blood. In these cases colour awakens a corresponding physical sensation, which undoubtedly works upon the soul.

If this were always the case, it would be easy to define

by association the effects of colour upon other senses than that of sight. One might say that keen yellow looks sour, because it recalls the taste of a lemon.

But such definitions are not universally possible. There are many examples of colour working which refuse to be so classified. A Dresden doctor relates of one of his patients, whom he designates as an " exceptionally sensitive person," that he could not eat a certain sauce without tasting "blue," *i.e.* without experiencing a feeling of seeing a blue colour.[1] It would be possible to suggest, by way of explanation of this, that in highly sensitive people, the way to the soul is so direct and the soul itself so impressionable, that any impression of taste communicates itself immediately to the soul, and thence to the other organs of sense (in this case, the eyes). This would imply an echo or reverberation, such as occurs sometimes in musical instruments which, without being touched, sound in harmony with some other instrument struck at the moment.

But not only with taste has sight been known to work in harmony. Many colours have been described as rough or sticky, others as smooth and uniform, so that one

[1] Dr. Freudenberg. Spaltung der Persönlichkeit (Übersinnliche Welt. 1908. No. 2, p. 64-65). The author also discusses the hearing of colour, and says that here also no rules can be laid down. But *cf.* L. Sabanejeff in " Musik," Moskow. 1911. No. 9, where the imminent possibility of laying down a law is clearly hinted at.

feels inclined to stroke them (*e.g.*, dark ultramarine, chrom-oxyde green, and rose madder). Equally the distinction between warm and cold colours belongs to this connection. Some colours appear soft (rose madder), others hard (cobalt green, blue-green oxide), so that even fresh from the tube they seem to be dry.

The expression " scented colours " is frequently met with. And finally the sound of colours is so definite that it would be hard to find anyone who would try to express bright yellow in the bass notes, or dark lake in the treble.[1,2] The explanation by association will not suffice us in many, and the most important cases. Those who have

[1] Much theory and practice have been devoted to this question. People have sought to paint in counterpoint. Also unmusical children have been successfully helped to play the piano by quoting a parallel in colour (*e.g.*, of flowers). On these lines Frau A. Sacharjin-Unkowsky has worked for several years and has evolved a method of " so describing sounds by natural colours, and colours by natural sounds, that colour could be heard and sound seen." The system has proved successful for several years both in the inventor's own school and the Conservatoire at St. Petersburg. Finally Skrjabin, on more spiritual lines, has paralleled sounds and colours in a chart not unlike that of Frau Unkowsky. In " Prometheus " he has given convincing proof of his theories. (His chart appeared in " Musik," Moskow, 1911, No. 9.)

[2] The converse question, *i.e.* the colour of sound, was touched upon by Mallarmé and systematized by his disciple René Ghil, whose book, "Traité du Verbe," gives the rules for " l'instrumentation verbale."— M. T. H. S.

heard of chromotherapy will know that coloured light
can exercise very definite influences on the whole body.
Attempts have been made with different colours in the
treatment of various nervous ailments. They have shown
that red light stimulates and excites the heart, while blue
light can cause temporary paralysis. But when the
experiments come to be tried on animals and even plants,
the association theory falls to the ground. So one is
bound to admit that the question is at present unexplored,
but that colour can exercise enormous influence over the
body as a physical organism.

No more sufficient, in the psychic sphere, is the theory of
association. Generally speaking, colour is a power which
directly influences the soul. Colour is the key-board, the
eyes are the hammers, the soul is the piano with many
strings. The artist is the hand which plays, touching one
key or another, to cause vibrations in the soul.

*It is evident therefore that colour harmony must rest only on
a corresponding vibration in the human soul; and this is one of
the guiding principles of the inner need.*[1]

[1] The phrase " inner need " (innere Notwendigkeit) means primarily the
impulse felt by the artist for spiritual expression. Kandinsky is apt, how-
ever, to use the phrase sometimes to mean not only the hunger for spiritual
expression, but also the actual expression itself.—M. T. H. S.

VI.

THE LANGUAGE OF
FORM AND COLOUR

The man that hath no music in himself,
Nor is not moved with concord of sweet sounds,
Is fit for treasons, stratagems, and spoils;
The motions of his spirit are dull as night,
And his affections dark as Erebus:
Let no such man be trusted. Mark the music.
(*Merchant of Venice*, Act v, Scene 1.)

MUSICAL sound acts directly on the soul and finds an echo there because, though to varying extents, music is innate in man.[1]

[1] Cf. E. Jacques-Dalcroze in " The Eurhythmics of Jacques-Dalcroze." London, Constable. 1s. net.—M. T. H. S.

Everyone knows that yellow, orange, and red suggest ideas of joy and plenty " (Delacroix).[1]

These two quotations show the deep relationship between the arts, and especially between music and painting. Goethe said that painting must count this relationship her main foundation, and by this prophetic remark he seems to foretell the position in which painting is to-day. She stands, in fact, at the first stage of the road by which she will, according to her own possibilities, make art an abstraction of thought and arrive finally at purely artistic composition.[2]

Painting has two weapons at her disposal :

1. Colour.

2. Form.

Form can stand alone as representing an object (either real or otherwise) or as a purely abstract limit to a space or a surface.

Colour cannot stand alone ; it cannot dispense with

[1] Cf. Paul Signac, " D'Eugène Delacroix au Néo-Impressionisme." Paris. Floury. 2 frs. Also compare an interesting article by K. Schettler : " Notizen über die Farbe." (" Decorative Kunst," 1901, February).

[2] By " Komposition " Kandinsky here means, of course, an artistic creation. He is not referring to the arrangement of the objects in a picture.—M. T. H. S.

boundaries of some kind.[1] A never-ending extent of red can only be seen in the mind; when the word red is heard, the colour is evoked without definite boundaries. If such are necessary they have deliberately to be imagined. But such red, as is seen by the mind and not by the eye, exercises at once a definite and an indefinite impression on the soul, and produces spiritual harmony. I say " indefinite," because in itself it has no suggestion of warmth or cold, such attributes having to be imagined for it afterwards, as modifications of the original "redness." I say "definite," because the spiritual harmony exists without any need for such subsequent attributes of warmth or cold. An analogous case is the sound of a trumpet which one hears when the word " trumpet " is pronounced. This sound is audible to the soul, without the distinctive character of a trumpet heard in the open air or in a room, played alone or with other instruments, in the hands of a postilion, a huntsman, a soldier, or a professional musician.

But when red is presented in a material form (as in

[1] Cf. A. Wallace Rimington. Colour music (*op*. *cit*.) where experiments are recounted with a colour organ, which gives symphonies of rapidly changing colour without boundaries—except the unavoidable ones of the white curtain on which the colours are reflected.—M. T. H. S.

painting) it must possess (1) some definite shade of the many shades of red that exist and (2) a limited surface, divided off from the other colours, which are undoubtedly there. The first of these conditions (the subjective) is affected by the second (the objective), for the neighbouring colours affect the shade of red.

This essential connection between colour and form brings us to the question of the influences of form on colour. Form alone, even though totally abstract and geometrical, has a power of inner suggestion. A triangle (without the accessory consideration of its being acute or obtuse-angled or equilateral) has a spiritual value of its own. In connection with other forms, this value may be somewhat modified, but remains in quality the same. The case is similar with a circle, a square, or any conceivable geometrical figure.[1] As above, with the red, we have here a subjective substance in an objective shell.

The mutual influence of form and colour now becomes clear. A yellow triangle, a blue circle, a green square, or a green triangle, a yellow circle, a blue square—all these are different and have different spiritual values.

[1] The angle at which the triangle stands, and whether it is stationary or moving, are of importance to its spiritual value. This fact is specially worthy of the painter's consideration.

Raphael. The Canigiani Holy Family

It is evident that many colours are hampered and even nullified in effect by many forms. On the whole, keen colours are well suited by sharp forms (*e.g.*, a yellow triangle), and soft, deep colours by round forms (*e.g.*, a blue circle). But it must be remembered that an unsuitable combination of form and colour is not necessarily discordant, but may, with manipulation, show the way to fresh possibilities of harmony.

Since colours and forms are well-nigh innumerable, their combination and their influences are likewise unending. The material is inexhaustible.

Form, in the narrow sense, is nothing but the separating line between surfaces of colour. That is its outer meaning. But it has also an inner meaning, of varying intensity,[1] and, properly speaking, *form is the outward expression of this inner meaning.* To use once more the metaphor of the piano—the artist is the hand which, by playing on this or that key (*i.e.*, form), affects the human soul in this or that way. *So it is evident that form-harmony must rest only on a corresponding vibration of the human soul; and this is a second guiding principle of the inner need.*

[1] It is never literally true that any form is meaningless and "says nothing." Every form in the world says something. But its message often fails to reach us, and even if it does, full understanding is often withheld from us.

The two aspects of form just mentioned define its two aims. The task of limiting surfaces (the outer aspect) is well performed if the inner meaning is fully expressed.[1] The outer task may assume many different shapes; but it will never fail in one of two purposes:

(1) Either form aims at so limiting surfaces as to fashion of them some material object;

(2) Or form remains abstract, describing only a non-material, spiritual entity. Such non-material entities, with life and value as such, are a circle, a triangle, a rhombus, a trapeze, etc., many of them so complicated as to have no mathematical denomination.

Between these two extremes lie the innumerable forms in which both elements exist; with a preponderance either of the abstract or the material. These intermediate forms are, at present, the store on which the artist has to draw. Purely abstract forms are beyond the reach of the artist at present; they are too indefinite for him. To limit himself to the purely indefinite would be to rob himself of possibilities, to exclude the human element and therefore to weaken his power of expression.

[1] The phrase, " full expression," must be clearly understood. Form often is most expressive when least coherent. It is often most expressive when outwardly most imperfect, perhaps only a stroke, a mere hint of outer meaning.

On the other hand, there exists equally no purely material form. A material object cannot be absolutely reproduced. For good or evil, the artist has eyes and hands, which are perhaps more artistic than his intentions and refuse to aim at photography alone. Many genuine artists, who cannot be content with a mere inventory of material objects, seek to express the objects by what was once called "idealization," then "selection," and which to-morrow will again be called something different.[1]

The impossibility and, in art, the uselessness of attempting to copy an object exactly, the desire to give the object full expression, are the impulses which drive the artist away from "literal" colouring to purely artistic aims. And that brings us to the question of composition.[2]

Pure artistic composition has two elements:

1. The composition of the whole picture.
2. The creation of the various forms which, by standing

[1] The motive of idealization is so to beautify the organic form as to bring out its harmony and rouse poetic feeling. "Selection" aims not so much at beautification as at emphasizing the character of the object, by the omission of non-essentials. The desire of the future will be purely the expression of the inner meaning. The organic form no longer serves as direct object, but as the human words in which a divine message must be written, in order for it to be comprehensible to human minds.

[2] Here Kandinsky means—arrangement of the picture.—M. T. H. S.

in different relationships to each other, decide the composition of the whole.[1] Many objects have to be considered in the light of the whole, and so ordered as to suit this whole. Singly they will have little meaning, being of importance only in so far as they help the general effect. These single objects must be fashioned in one way only; and this, not because their own inner meaning demands that particular fashioning, but entirely because they have to serve as building-material for the whole composition.[2]

So the abstract idea is creeping into art, although, only yesterday, it was scorned and obscured by purely material ideals. Its gradual advance is natural enough, for in pro-

[1] The general composition will naturally include many little compositions which may be antagonistic to each other, though helping—perhaps by their very antagonism—the harmony of the whole. These little compositions have themselves subdivisions of varied inner meanings.

[2] A good example is Cézanne's Bathing Women, which is built in the form of a triangle. Such building is an old principle, which was being abandoned only because academic usage had made it lifeless. But Cézanne has given it new life. He does not use it to harmonize his groups, but for purely artistic purposes. He distorts the human figure with perfect justification. Not only must the whole figure follow the lines of the triangle, but each limb must grow narrower from bottom to top. Raphael's "Holy Family" is an example of triangular composition used only for the harmonizing of the group, and without any mystical motive.

Cézanne. Bathing Women

portion as the organic form falls into the background, the abstract ideal achieves greater prominence.

But the organic form possesses all the same an inner harmony of its own, which may be either the same as that of its abstract parallel (thus producing a simple combination of the two elements) or totally different (in which case the combination may be unavoidably discordant). However diminished in importance the organic form may be, its inner note will always be heard; and for this reason the choice of material objects is an important one. The spiritual accord of the organic with the abstract element may strengthen the appeal of the latter (as much by contrast as by similarity) or may destroy it.

Suppose a rhomboidal composition, made up of a number of human figures. The artist asks himself: Are these human figures an absolute necessity to the composition, or should they be replaced by other forms, and that without affecting the fundamental harmony of the whole? If the answer is " Yes," we have a case in which the material appeal directly weakens the abstract appeal. The human form must either be replaced by another object which, whether by similarity or contrast, will strengthen the abstract appeal, or must remain a purely non-material symbol.[1]

[1] See, pp. xxxviii and xli

Once more the metaphor of the piano. For "colour" or "form" substitute "object." Every object has its own life and therefore its own appeal; man is continually subject to these appeals. But the results are often dubbed either sub- or super-conscious. Nature, that is to say the ever-changing surroundings of man, sets in vibration the strings of the piano (the soul) by manipulation of the keys (the various objects with their several appeals).

The impressions we receive, which often appear merely chaotic, consist of three elements: the impression of the colour of the object, of its form, and of its combined colour and form, *i.e.* of the object itself.

At this point the individuality of the artist comes to the front and disposes, as he wills, these three elements. *It is clear, therefore, that the choice of object* (i.e. *of one of the elements in the harmony of form*) *must be decided only by a corresponding vibration in the human soul; and this is a third guiding principle of the inner need.*

The more abstract is form, the more clear and direct is its appeal. In any composition the material side may be more or less omitted in proportion as the forms used are more or less material, and for them substituted pure abstractions, or largely dematerialized objects. The more an

artist uses these abstracted forms, the deeper and more confidently will he advance into the kingdom of the abstract. And after him will follow the gazer at his pictures, who also will have gradually acquired a greater familiarity with the language of that kingdom.

Must we then abandon utterly all material objects and paint solely in abstractions? The problem of harmonizing the appeal of the material and the non-material shows us the answer to this question. As every word spoken rouses an inner vibration, so likewise does every object represented. To deprive oneself of this possibility is to limit one's powers of expression. That is at any rate the case at present. But besides this answer to the question, there is another, and one which art can always employ to any question beginning with " must ": There is no " must " in art, because art is free.

With regard to the second problem of composition, the creation of the single elements which are to compose the whole, it must be remembered that the same form in the same circumstances will always have the same inner appeal. Only the circumstances are constantly varying. It results that: (1) The ideal harmony alters according to the relation to other forms of the form which causes it. (2) Even in similar relationship a slight approach to or withdrawal

from other forms may affect the harmony.[1] Nothing is absolute. Form-composition rests on a relative basis, depending on (1) the alterations in the mutual relations of forms one to another, (2) alterations in each individual form, down to the very smallest. Every form is as sensitive as a puff of smoke, the slightest breath will alter it completely. This extreme mobility makes it easier to obtain similar harmonies from the use of different forms, than from a repetition of the same one; though of course an exact replica of a spiritual harmony can never be produced. So long as we are susceptible only to the appeal of a whole composition, this fact is of mainly theoretical importance. But when we become more sensitive by a constant use of abstract forms (which have no material interpretation) it will become of great practical significance. And so as art becomes more difficult, its wealth of expression in form becomes greater and greater. At the same time the question of distortion in drawing falls out and is replaced by the question how far the inner appeal of the particular form is veiled or given full expression. And once more the possibilities are extended, for combinations of veiled and

[1] This is what is meant by " an appeal of motion." For example, the appeal of an upright triangle is more steadfast and quiet than that of one set obliquely on its side.

fully expressed appeals suggest new *leit motiven* in composition.

Without such development as this, form-composition is impossible. To anyone who cannot experience the inner appeal of form (whether material or abstract) such composition can never be other than meaningless. Apparently aimless alterations in form-arrangement will make art seem merely a game. So once more we are faced with the same principle, which is to set art free, the principle of the inner need.

When features or limbs for artistic reasons are changed or distorted, men reject the artistic problem and fall back on the secondary question of anatomy. But, on our argument, this secondary consideration does not appear, only the real, artistic question remaining. These apparently irresponsible, but really well-reasoned alterations in form provide one of the storehouses of artistic possibilities.

The adaptability of forms, their organic but inward variations, their motion in the picture, their inclination to material or abstract, their mutual relations, either individually or as parts of a whole; further, the concord or discord of the various elements of a picture, the handling of groups, the combinations of veiled and openly expressed appeals, the use of rhythmical or unrhythmical,

of geometrical or non-geometrical forms, their contiguity or separation—all these things are the material for counter-point in painting.

But so long as colour is excluded, such counterpoint is confined to black and white. Colour provides a whole wealth of possibilities of her own, and when combined with form, yet a further series of possibilities. And all these will be expressions of the inner need.

* *

*

The inner need is built up of three mystical elements: (1) Every artist, as a creator, has something in him which calls for expression (this is the element of personality). (2) Every artist, as child of his age, is impelled to express the spirit of his age (this is the element of style)—dictated by the period and particular country to which the artist belongs (it is doubtful how long the latter distinction will continue to exist). (3) Every artist, as a servant of art, has to help the cause of art (this is the element of pure artistry, which is constant in all ages and among all nationalities).

A full understanding of the first two elements is neces-sary for a realization of the third. But he who has this realization will recognize that a rudely-carved Indian

column is an expression of the same spirit as actuates any real work of art of to-day.

In the past and even to-day much talk is heard of " personality " in art. Talk of the coming " style " becomes more frequent daily. But for all their importance to-day, these questions will have disappeared after a few hundred or thousand years.

Only the third element—that of pure artistry—will remain for ever. An Egyptian carving speaks to us to-day more subtly than it did to its chronological contemporaries; for they judged it with the hampering knowledge of period and personality. But we can judge purely as an expression of the eternal artistry.

Similarly—the greater the part played in a modern work of art by the two elements of style and personality, the better will it be appreciated by people to-day; but a modern work of art which is full of the third element, will fail to reach the contemporary soul. For many centuries have to pass away before the third element can be received with understanding. But the artist in whose work this third element predominates is the really great artist.

Because the elements of style and personality make up what is called the periodic characteristics of any work of

art, the "development" of artistic forms must depend on their separation from the element of pure artistry, which knows neither period nor nationality. But as style and personality create in every epoch certain definite forms, which, for all their superficial differences, are really closely related, these forms can be spoken of as one side of art—the *subjective*. Every artist chooses, from the forms which reflect his own time, those which are sympathetic to him, and expresses himself through them. So the subjective element is the definite and external expression of the inner, objective element.

The inevitable desire for outward expression of the *objective* element is the impulse here defined as the "inner need." The forms it borrows change from day to day, and, as it continually advances, what is to-day a phrase of inner harmony becomes to-morrow one of outer harmony. It is clear, therefore, that the inner spirit of art only uses the outer form of any particular period as a stepping-stone to further expression.

In short, the working of the inner need and the development of art is an ever-advancing expression of the eternal and objective in the terms of the periodic and subjective.

Because the objective is for ever exchanging the subjective expression of to-day for that of to-morrow, each

new extension of liberty in the use of outer form is hailed as the last and supreme. At present we say that an artist can use any form he wishes, so long as he remains in touch with nature. But this limitation, like all its predecessors, is only temporary. From the point of view of the inner need, no limitation must be made. The artist may use any form which his expression demands; for his inner impulse must find suitable outward expression.

So we see that a deliberate search for personality and "style" is not only impossible, but comparatively unimportant. The close relationship of art throughout the ages, is not a relationship in outward form but in inner meaning. And therefore the talk of schools, of lines of "development," of "principles of art," etc., is based on misunderstanding and can only lead to confusion.

The artist must be blind to distinctions between "recognized" or "unrecognized" conventions of form, deaf to the transitory teaching and demands of his particular age. He must watch only the trend of the inner need, and hearken to its words alone. Then he will with safety employ means both sanctioned and forbidden by his contemporaries. All means are sacred which are called for by the inner need. All means are sinful which obscure that inner need.

It is impossible to theorize about this ideal of art. In
real art theory does not precede practice, but follows her.
Everything is, at first, a matter of feeling. Any theoretical
scheme will be lacking in the essential of creation—the
inner desire for expression—which cannot be determined.
Neither the quality of the inner need, nor its subjective
form, can be measured nor weighed.[1] Such a grammar of
painting can only be temporarily guessed at, and should
it ever be achieved, it will be not so much according to
physical rules (which have so often been tried and which
to-day the Cubists are trying) as according to the rules of
the inner need, which are of the soul.

* *

*

The inner need is the basis alike of small and great
problems in painting. We are seeking to-day for the
road which is to lead us away from the outer[2] to the

[1] The many-sided genius of Leonardo devised a system of little spoons
with which different colours were to be used, thus creating a kind of
mechanical harmony. One of his pupils, after trying in vain to use this
system, in despair asked one of his colleagues how the master himself used
the invention. The colleague replied : "The master never uses it at all."
(Mereschowski, "Leonardo da Vinci ").

[2] The term "outer," here used, must not be confused with the term
"material" used previously. I am using the former to mean "outer need,"

inner basis. The spirit, like the body, can be strengthened and developed by frequent exercise. Just as the body, if neglected, grows weaker and finally impotent, so the spirit perishes if untended. And for this reason it is necessary for the artist to know the starting point for the exercise of his spirit.

The starting point is the study of colour and its effects on men.

There is no need to engage in the finer shades of complicated colour, but rather at first to consider only the direct use of simple colours.

To begin with, let us test the working on ourselves of individual colours, and so make a simple chart, which will facilitate the consideration of the whole question.

Two great divisions of colour occur to the mind at the outset : into warm and cold, and into light and dark. To each colour there are therefore four shades of appeal—

which never goes beyond conventional limits, nor produces other than conventional beauty. The "inner need" knows no such limits, and often produces results conventionally considered "ugly." But "ugly" itself is a conventional term, and only means "spiritually unsympathetic," being applied to some expression of an inner need, either outgrown or not yet attained. But everything which adequately expresses the inner need is beautiful.

warm and light or warm and dark, or cold and light or cold and dark.

Generally speaking, warmth or cold in a colour means an approach respectively to yellow or to blue. This distinction is, so to speak, on one basis, the colour having a constant fundamental appeal, but assuming either a more material or more non-material quality. The movement is an horizontal one, the warm colours approaching the spectator, the cold ones retreating from him.

The colours, which cause in another colour this horizontal movement, while they are themselves affected by it, have another movement of their own, which acts with a violent separative force. This is, therefore, the first antithesis in the inner appeal, and the inclination of the colour to yellow or to blue, is of tremendous importance.

The second antithesis is between white and black; i.e., the inclination to light or dark caused by the pair of colours just mentioned. These colours have once more their peculiar movement to and from the spectator, but in a more rigid form (see Fig. 1).

Yellow and blue have another movement which affects the first antithesis—an ex- and concentric movement. If two circles are drawn and painted respectively yellow and blue, brief concentration will reveal in the yellow a

FIGURE I

First Pair of antitheses. (inner appeal acting on
 A and B. the spirit)

A. Warm Cold
 Yellow Blue = First antithesis

 Two movements :
 (i) *horizontal*

Towards the spectator ←————————《《 》》————————→ Away from the spectator
 (bodily) (spiritual)

 (ii) *ex-* *and* *concentric*

B. Light Dark
 White Black = Second antithesis

 Two movements :
 (i) *discordant*

Eternal discord, but with Absolute discord, devoid
 possibilities for the White Black of possibilities for the
 future (birth) future (death)

 (ii) *ex- and concentric, as in case of yellow and blue, but*
 more rigid.

spreading movement out from the centre, and a notice-able approach to the spectator. The blue, on the other hand, moves in upon itself, like a snail retreating into its shell, and draws away from the spectator.[1]

In the case of light and dark colours the movement is emphasized. That of the yellow increases with an admixture of white, *i.e.*, as it becomes lighter. That of the blue increases with an admixture of black, *i.e.*, as it becomes darker. This means that there can never be a dark-coloured yellow. The relationship between white and yellow is as close as between black and blue, for blue can be so dark as to border on black. Besides this physical relationship, is also a spiritual one (between yellow and white on one side, between blue and black on the other) which marks a strong separation between the two pairs.

An attempt to make yellow colder produces a green tint and checks both the horizontal and excentric move-ment. The colour becomes sickly and unreal. The blue by its contrary movement acts as a brake on the yellow, and is hindered in its own movement, till the two together become stationary, and the result is green. Similarly

[1] These statements have no scientific basis, but are founded purely on spiritual experience.

a mixture of black and white produces gray, which is motionless and spiritually very similar to green.

But while green, yellow, and blue are potentially active, though temporarily paralysed, in gray is no possibility of movement, because gray consists of two colours that have no active force, for they stand the one in motionless discord, the other in a motionless negation, even of discord, like an endless wall or a bottomless pit.

Because the component colours of green are active and have a movement of their own, it is possible, on the basis of this movement, to reckon their spiritual appeal.

The first movement of yellow, that of approach to the spectator (which can be increased by an intensification of the yellow), and also the second movement, that of over-spreading the boundaries, have a material parallel in the human energy which assails every obstacle blindly, and bursts forth aimlessly in every direction.

Yellow, if steadily gazed at in any geometrical form, has a disturbing influence, and reveals in the colour an insistent, aggressive character.[1] The intensification of the yellow increases the painful shrillness of its note.[2]

[1] It is worth noting that the sour-tasting lemon and shrill-singing canary are both yellow.

[2] Any parallel between colour and music can only be relative. Just as a violin can give various shades of tone, so yellow has shades, which can be

Yellow is the typically earthly colour. It can never have profound meaning. An intermixture of blue makes it a sickly colour. It may be paralleled in human nature, with madness, not with melancholy or hypochondriacal mania, but rather with violent raving lunacy.

The power of profound meaning is found in blue, and first in its physical movements (1) of retreat from the spectator, (2) of turning in upon its own centre. The inclination of blue to depth is so strong that its inner appeal is stronger when its shade is deeper.

Blue is the typical heavenly colour.[1] The ultimate feeling it creates is one of rest.[2] When it sinks almost to black, it echoes a grief that is hardly human.[3] When it rises towards white, a movement little suited to it, its

expressed by various instruments. But in making such parallels, I am assuming in each case a pure tone of colour or sound, unvaried by vibration or dampers, etc.

[1] . . . The halos are golden for emperors and prophets (*i.e.* for mortals), and sky-blue for symbolic figures (*i.e.* spiritual beings); (Kondakoff, " Histoire de l'Art Byzantine considerée principalement dans les miniatures," vol. ii, p. 382, Paris, 1886-91).

[2] Supernatural rest, not the earthly contentment of green. The way to the supernatural lies through the natural. And we mortals passing from the earthly yellow to the heavenly blue must pass through green.

[3] As an echo of grief violet stands to blue as does green in its production of rest.

appeal to men grows weaker and more distant. In music
a light blue is like a flute, a darker blue a 'cello; a still
darker a thunderous double bass; and the darkest blue of
all—an organ.

A well balanced mixture of blue and yellow produces
green. The horizontal movement ceases; likewise that
from and towards the centre. The effect on the soul
through the eye is therefore motionless. This is a fact
recognized not only by opticians but by the world. Green
is the most restful colour that exists. On exhausted men
this restfulness has a beneficial effect, but after a time it
becomes wearisome. Pictures painted in shades of green are
passive and tend to be wearisome; this contrasts with the
active warmth of yellow or the active coolness of blue. In
the hierarchy of colours green is the "bourgeoisie"—
self-satisfied, immovable, narrow. It is the colour of
summer, the period when nature is resting from the
storms of winter and the productive energy of spring (cf.
Fig. 2).

Any preponderance in green of yellow or blue introduces
a corresponding activity and changes the inner appeal.
The green keeps its characteristic equanimity and restful-
ness, the former increasing with the inclination to light-
ness, the latter with the inclination to depth. In music

FIGURE II

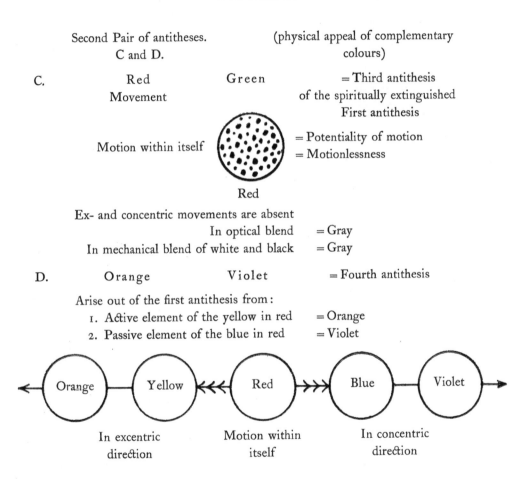

Second Pair of antitheses.
C and D.

(physical appeal of complementary colours)

C. Red Green = Third antithesis
 Movement of the spiritually extinguished
 First antithesis

Motion within itself = Potentiality of motion
 = Motionlessness

Red

Ex- and concentric movements are absent
In optical blend = Gray
In mechanical blend of white and black = Gray

D. Orange Violet = Fourth antithesis

Arise out of the first antithesis from:
 1. Active element of the yellow in red = Orange
 2. Passive element of the blue in red = Violet

Orange — Yellow — Red — Blue — Violet

In excentric Motion within In concentric
direction itself direction

the absolute green is represented by the placid, middle notes of a violin.

Black and white have already been discussed in general terms. More particularly speaking, white, although often considered as no colour (a theory largely due to the impressionists, who saw no white in nature[1]), is a symbol of a world from which all colour as a definite attribute has disappeared. This world is too far above us for its harmony to touch our souls. A great silence, like an impenetrable wall, shrouds its life from our understanding. White, therefore, has this harmony of silence, which works upon us negatively, like many pauses in music that break temporarily the melody. It is not a dead silence, but one pregnant with possibilities. White has the appeal of the nothingness that is before birth, of the world in the ice age.

A totally dead silence, on the other hand, a silence with

[1] Van Gogh, in his letters, asks whether he may not paint a white wall dead white. This question offers no difficulty to the non-representative artist who is concerned only with the inner harmony of colour. But to the impressionist-realist it seems a bold liberty to take with nature. To him it seems as outrageous as his own change from brown shadows to blue seemed to his contemporaries. Van Gogh's question marks a transition from impressionism to an art of spiritual harmony, as the coming of the blue shadow marked a transition from academism to impressionism. (Cf. "The Letters of Vincent van Gogh." Constable, London, 7s. 6d. net.)

no possibilities, has the inner harmony of *black*. In music
it is represented by one of those profound and final pauses,
after which any continuation of the melody seems the
dawn of another world. Black is something burnt out,
like the ashes of a funeral pyre, something motionless like
a corpse. The silence of black is the silence of death.
Outwardly black is the colour with least harmony of all,
a kind of neutral background against which the minutest
shades of other colours stand clearly forward. It differs from
white in this also, for with white nearly every colour is in
discord, or even mute altogether.[1]

Not without reason is white taken as symbolizing joy
and spotless purity, and black grief and death. A blend of
black and white produces gray, which, as has been said, is
silent and motionless, being composed of two inactive
colours, its restfulness having none of the potential activity
of green. A similar gray is produced by a mixture of
green and red, a spiritual blend of passivity and glowing
warmth.[2]

The unbounded warmth of *red* has not the irresponsible

[1] *E.g.* vermilion rings dull and muddy against white, but against black
with clear strength. Light yellow against white is weak, against black
pure and brilliant.

[2] Gray = immobility and rest. Delacroix sought to express rest by a
mixture of green and red (cf. Signac, *sup. cit.*).

appeal of yellow, but rings inwardly with a determined and powerful intensity. It glows in itself, maturely, and does not distribute its vigour aimlessly (see Fig. 2).

The varied powers of red are very striking. By a skilful use of it in its different shades, its fundamental tone may be made warm or cold.[1]

Light warm red has a certain similarity to medium yellow, alike in texture and appeal, and gives a feeling of strength, vigour, determination, triumph. In music, it is a sound of trumpets, strong, harsh, and ringing.

Vermilion is a red with a feeling of sharpness, like glowing steel which can be cooled by water. Vermilion is quenched by blue, for it can support no mixture with a cold colour. More accurately speaking, such a mixture produces what is called a dirty colour, scorned by painters of to-day. But "dirt" as a material object has its own inner appeal, and therefore to avoid it in painting, is as unjust and narrow as was the cry of yesterday for pure colour. At the call of the inner need, that which is outwardly foul may be inwardly pure, and *vice versa*.

The two shades of red just discussed are similar to yellow, except that they reach out less to the spectator.

[1] Of course every colour can be to some extent varied between warm and cold, but no colour has so extensive a scale of varieties as red.

The glow of red is within itself. For this reason it is a colour more beloved than yellow, being frequently used in primitive and traditional decoration, and also in peasant costumes, because in the open air the harmony of red and green is very beautiful. Taken by itself this red is material, and, like yellow, has no very deep appeal. Only when combined with something nobler does it acquire this deep appeal. It is dangerous to seek to deepen red by an admixture of black, for black quenches the glow, or at least reduces it considerably.

But there remains brown, unemotional, disinclined for movement. An intermixture of red is outwardly barely audible, but there rings out a powerful inner harmony. Skilful blending can produce an inner appeal of extraordinary, indescribable beauty. The vermilion now rings like a great trumpet, or thunders like a drum.

Cool red (madder) like any other fundamentally cold colour, can be deepened—especially by an intermixture of azure. The character of the colour changes; the inward glow increases, the active element gradually disappears. But this active element is never so wholly absent as in deep green. There always remains a hint of renewed vigour, somewhere out of sight, waiting for a certain moment to burst forth afresh. In this lies the great

difference between a deepened red and a deepened blue, because in red there is always a trace of the material. A parallel in music are the sad, middle tones of a 'cello. A cold, light red contains a very distinct bodily or material element, but it is always pure, like the fresh beauty of the face of a young girl. The singing notes of a violin express this exactly in music.

Warm red, intensified by a suitable yellow, is *orange*. This blend brings red almost to the point of spreading out towards the spectator. But the element of red is always sufficiently strong to keep the colour from flippancy. Orange is like a man, convinced of his own powers. Its note is that of the angelus, or of an old violin.

Just as orange is red brought nearer to humanity by yellow, so violet is red withdrawn from humanity by blue. But the red in violet must be cold, for the spiritual need does not allow of a mixture of warm red with cold blue.

Violet is therefore both in the physical and spiritual sense a cooled red. It is consequently rather sad and ailing. It is worn by old women, and in China as a sign of mourning. In music it is an English horn, or the deep notes of wood instruments (*e.g.* a bassoon).[1]

[1] Among artists one often hears the question, "How are you?" answered gloomily by the words "Feeling very violet."

The two last mentioned colours (orange and violet) are the fourth and last pair of antitheses of the primitive colours. They stand to each other in the same relation as the third antitheses—green and red—*i.e.*, as complementary colours (see Fig. 2).

As in a great circle, a serpent biting its own tail (the symbol of eternity, of something without end) the six colours appear that make up the three main antitheses. And to right and left stand the two great possibilities of silence—death and birth (see Fig. 3).

* *

*

It is clear that all I have said of these simple colours is very provisional and general, and so also are those feelings (joy, grief, etc.) which have been quoted as parallels of the colours. For these feelings are only the material expressions of the soul. Shades of colour, like those of sound, are of a much finer texture and awake in the soul emotions too fine to be expressed in words. Certainly each tone will find some probable expression in words, but it will always be incomplete, and that part which the word fails to express will not be unimportant but rather the very kernel of its existence. For this reason words are, and will always

FIGURE III

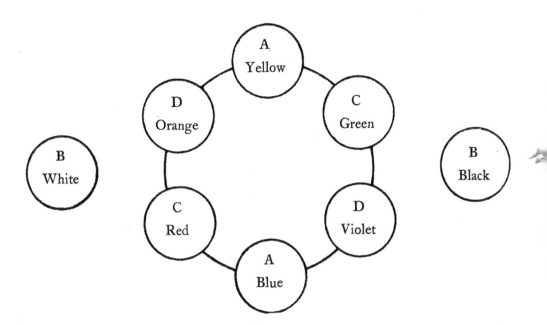

The antitheses as a circle between two poles, *i.e.*, the life of colours between birth and death.

(The capital letters designate the pairs of antitheses.)

remain, only hints, mere suggestions of colours. In this impossibility of expressing colour in words with the consequent need for some other mode of expression lies the opportunity of the art of the future. In this art among innumerable rich and varied combinations there is one which is founded on firm fact, and that is as follows. The actual expression of colour can be achieved simultaneously by several forms of art, each art playing its separate part, and producing a whole which exceeds in richness and force any expression attainable by one art alone. The immense possibilities of depth and strength to be gained by combination or by discord between the various arts can be easily realized.

It is often said that the admission of the possibility of one art helping another amounts to a denial of the necessary differences between the arts. This is, however, not the case. As has been said, an absolutely similar inner appeal cannot be achieved by two different arts. Even if it were possible the second version would differ at least outwardly. But suppose this were not the case, that is to say, suppose a repetition of the same appeal exactly alike both outwardly and inwardly could be achieved by different arts, such repetition would not be merely superfluous. To begin with, different people find sympathy in different

forms of art (alike on the active and passive side among
the creators or the receivers of the appeal); but further
and more important, repetition of the same appeal thickens
the spiritual atmosphere which is necessary for the matur-
ing of the finest feelings, in the same way as the hot air of
a greenhouse is necessary for the ripening of certain fruit.
An example of this is the case of the individual who receives
a powerful impression from constantly repeated actions,
thoughts or feelings, although if they came singly they
might have passed by unnoticed.[1] We must not, however,
apply this rule only to the simple examples of the spiritual
atmosphere. For this atmosphere is like air, which can be
either pure or filled with various alien elements. Not only
visible actions, thoughts and feelings, with outward ex-
pression, make up this atmosphere, but secret happenings
of which no one knows, unspoken thoughts, hidden feel-
ings are also elements in it. Suicide, murder, violence,
low and unworthy thoughts, hate, hostility, egotism, envy,
narrow " patriotism," partisanship, are elements in the
spiritual atmosphere.[2]

And conversely, self-sacrifice, mutual help, lofty

[1] This idea forms, of course, the fundamental reason for advertisement.
[2] Epidemics of suicide or of violent warlike feeling, etc., are products of
this impure atmosphere.

thoughts, love, unselfishness, joy in the success of others, humanity, justness, are the elements which slay those already enumerated as the sun slays the microbes, and restore the atmosphere to purity.[1]

The second and more complicated form of repetition is that in which several different elements make mutual use of different forms. In our case these elements are the different arts summed up in the art of the future. And this form of repetition is even more powerful, for the different natures of men respond to the different elements in the combination. For one the musical form is the most moving and impressive; for another the pictorial, for the third the literary, and so on. There reside, therefore, in arts which are outwardly different, hidden forces equally different, so that they may all work in one man towards a single result, even though each art may be working in isolation.

This sharply defined working of individual colours is the basis on which various values can be built up in harmony. Pictures will come to be painted—veritable artistic arrangements, planned in shades of one colour chosen according to artistic feeling. The carrying out of one colour, the binding together and admixture of two related colours,

[1] These elements likewise have their historical periods.

are the foundations of most coloured harmonies. From what
has been said above about colour working, from the fact
that we live in a time of questioning, experiment and con-
tradiction, we can draw the easy conclusion that for a
harmonization on the basis of individual colours our age
is especially unsuitable. Perhaps with envy and with a
mournful sympathy we listen to the music of Mozart.
It acts as a welcome pause in the turmoil of our inner life,
as a consolation and as a hope, but we hear it as the echo
of something from another age long past and fundamentally
strange to us. The strife of colours, the sense of balance
we have lost, tottering principles, unexpected assaults,
great questions, apparently useless striving, storm and
tempest, broken chains, antitheses and contradictions, these
make up our harmony. *The composition arising from this har-
mony is a mingling of colour and form each with its separate
existence, but each blended into a common life which is called a
picture by the force of the inner need.* Only these individual
parts are vital. Everything else (such as surrounding con-
ditions) is subsidiary. The combination of two colours is
a logical outcome of modern conditions. The combination
of colours hitherto considered discordant, is merely a further
development. For example, the use, side by side, of red
and blue, colours in themselves of no physical relationship,

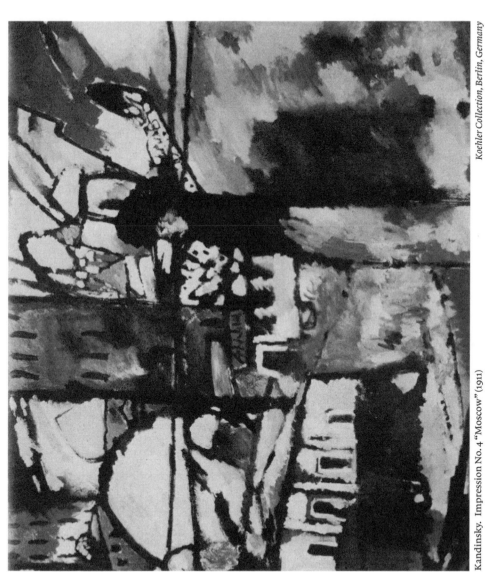

Kandinsky. Impression No. 4 "Moscow" (1911)

but from their very spiritual contrast of the strongest effect, is one of the most frequent occurrences in modern choice of harmony.[1] Harmony to-day rests chiefly on the principle of contrast which has for all time been one of the most important principles of art. But our contrast is an inner contrast which stands alone and rejects the help (for that help would mean destruction) of any other principles of harmony. It is interesting to note that this very placing together of red and blue was so beloved by the primitive both in Germany and Italy that it has till to-day survived, principally in folk pictures of religious subjects. One often sees in such pictures the Virgin in a red gown and a blue cloak. It seems that the artists wished to express the grace of heaven in terms of humanity, and humanity in terms of heaven. Legitimate and illegitimate combinations of colours, contrasts of various colours, the over-painting of one colour with another, the definition of coloured surfaces by boundaries of various forms, the overstepping of these boundaries, the mingling and the sharp separation of surfaces, all these open great vistas of artistic possibility.

One of the first steps in the turning away from material

[1] Cf. Gauguin. Noa noa—where the artist states his disinclination when he first arrived in Tahiti to juxtapose red and blue.

objects into the realm of the abstract was, to use the
technical artistic term, the rejection of the third dimension,
that is to say, the attempt to keep a picture on a single
plane. Modelling was abandoned. In this way the material
object was made more abstract and an important step
forward was achieved—this step forward has, however,
had the effect of limiting the possibilities of painting to
one definite piece of canvas, and this limitation has not
only introduced a very material element into painting, but
has seriously lessened its possibilities.

Any attempt to free painting from this material limita-
tion together with the striving after a new form of com-
position must concern itself first of all with the destruction
of this theory of one single surface—attempts must be
made to bring the picture on to some ideal plane which
shall be expressed in the terms of the material plane of
the canvas.[1] There has arisen out of the composition in
flat triangles a composition with plastic three dimensional
triangles, that is to say with pyramids; and that is Cubism.
But there has arisen here also the tendency to inertia, to a
concentration on this form for its own sake, and con-
sequently once more to an impoverishment of possibility.

[1] Compare the article by Le Fauconnier in the catalogue of the second
exhibition of the Neue Künstlervereinigung, Munich, 1910-11.

But that is the unavoidable result of the external application of an inner principle.

A further point of great importance must not be forgotten. There are other means of using the material plane as a space of three dimensions in order to create an ideal plane. The thinness or thickness of a line, the placing of the form on the surface, the overlaying of one form on another may be quoted as examples of artistic means that may be employed. Similar possibilities are offered by colour which, when rightly used, can advance or retreat, and can make of the picture a living thing, and so achieve an artistic expansion of space. The combination of both means of extension in harmony or concord is one of the richest and most powerful elements in purely artistic composition.

VII.

THEORY

FROM the nature of modern harmony, it results that never has there been a time when it was more difficult than it is to-day to formulate a complete theory,[1] or to lay down a firm artistic basis. All attempts to do so

[1] Attempts have been made. Once more emphasis must be laid on the parallel with music. For example, cf. "Tendances Nouvelles," No. 35, Henri Ravel: "The laws of harmony are the same for painting and music."

would have one result, namely, that already cited in the case of Leonardo and his system of little spoons. It would, however, be precipitate to say that there are no basic principles nor firm rules in painting, or that a search for them leads inevitably to academism. Even music has a grammar, which, although modified from time to time, is of continual help and value as a kind of dictionary.

Painting is, however, in a different position. The revolt from dependence on nature is only just beginning. Any realization of the inner working of colour and form is so far unconscious. The subjection of composition to some geometrical form is no new idea (cf. the art of the Persians). Construction on a purely abstract basis is a slow business, and at first seemingly blind and aimless. The artist must train not only his eye but also his soul, so that he can test colours for themselves and not only by external impressions.

If we begin at once to break the bonds which bind us to nature, and devote ourselves purely to combination of pure colour and abstract form, we shall produce works which are mere decoration, which are suited to neckties or carpets. Beauty of Form and Colour is no sufficient aim by itself, despite the assertions of pure aesthetes or even of naturalists, who are obsessed with the idea of

"beauty." It is because of the elementary stage reached
by our painting that we are so little able to grasp the
inner harmony of true colour and form composition. The
nerve vibrations are there, certainly, but they get no further
than the nerves, because the corresponding vibrations of
the spirit which they call forth are too weak. When we
remember, however, that spiritual experience is quicken-
ing, that positive science, the firmest basis of human
thought, is tottering, that dissolution of matter is imminent,
we have reason to hope that the hour of pure composition
is not far away.

It must not be thought that pure decoration is lifeless.
It has its inner being, but one which is either incom-
prehensible to us, as in the case of old decorative art,
or which seems mere illogical confusion, as a world in
which full-grown men and embryos play equal *rôles,* in
which beings deprived of limbs are on a level with noses
and toes which live isolated and of their own vitality.
The confusion is like that of a kaleidoscope, which
though possessing a life ot its own, belongs to another
sphere. Nevertheless, decoration has its effect on us;
oriental decoration quite differently to Swedish, savage,
or ancient Greek. It is not for nothing that there is a
general custom of describing samples of decoration as

gay, serious, sad, etc., as music is described as Allegro, Serioso, etc., according to the nature of the piece.

Probably conventional decoration had its beginnings in nature. But when we would assert that external nature is the sole source of all art, we must remember that, in patterning, natural objects are used as symbols, almost as though they were mere hieroglyphics. For this reason we cannot gauge their inner harmony. For instance, we can bear a design of Chinese dragons in our dining or bed rooms, and are no more disturbed by it than by a design of daisies.

It is possible that towards the close of our already dying epoch a new decorative art will develop, but it is not likely to be founded on geometrical form. At the present time any attempt to define this new art would be as useless as pulling a small bud open so as to make a fully-blown flower. Nowadays we are still bound to external nature and must find our means of expression in her. But how are we to do it? In other words, how far may we go in altering the forms and colours of this nature?

We may go as far as the artist is able to carry his emotion, and once more we see how immense is the need for true emotion. A few examples will make the meaning of this clearer.

A warm red tone will materially alter in inner value
when it is no longer considered as an isolated colour, as
something abstract, but is applied as an element of some
other object, and combined with natural form. The
variety of natural forms will create a variety of spiritual
values, all of which will harmonize with that of the
original isolated red. Suppose we combine red with sky,
flowers, a garment, a face, a horse, a tree.

A red sky suggests to us sunset, or fire, and has a con-
sequent effect upon us—either of splendour or menace.
Much depends now on the way in which other objects
are treated in connection with this red sky. If the treat-
ment is faithful to nature, but all the same harmonious,
the " naturalistic " appeal of the sky is strengthened. If,
however, the other objects are treated in a way which is
more abstract, they tend to lessen, if not to destroy, the
naturalistic appeal of the sky. Much the same applies to
the use of red in a human face. In this case red can be
employed to emphasize the passionate or other charac-
teristics of the model, with a force that only an ex-
tremely abstract treatment of the rest of the picture can
subdue.

A red garment is quite a different matter; for it can
in reality be of any colour. Red will, however, be found

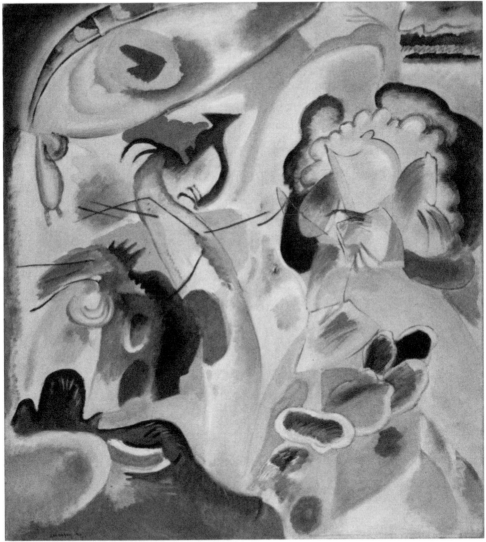

Kandinsky. Improvisation No. 29 (1912) *A. J. Eddy Collection, Chicago, U.S.A.*

best to supply the needs of pure artistry, for here alone can it be used without any association with material aims. The artist has to consider not only the value of the red cloak by itself, but also its value in connection with the figure wearing it, and further the relation of the figure to the whole picture. Suppose the picture to be a sad one, and the red-cloaked figure to be the central point on which the sadness is concentrated—either from its central position, or features, attitude, colour, or what not. The red will provide an acute discord of feeling, which will emphasize the gloom of the picture. The use of a colour, in itself sad, would weaken the effect of the dramatic whole.[1] This is the principle of antithesis already defined. Red by itself cannot have a sad effect on the spectator, and its inclusion in a sad picture will, if properly handled, provide the dramatic element.[2]

Yet again is the case of a red tree different. The fundamental value of red remains, as in every case. But the association of " autumn " creeps in. The colour combines

[1] Once more it is wise to emphasize the necessary inadequacy of these examples. Rules cannot be laid down, the variations are so endless. A single line can alter the whole composition of a picture.

[2] The use of terms like " sad " and " joyful " are only clumsy equivalents for the delicate spiritual vibrations of the new harmony. They must be read as necessarily inadequate.

easily with this association, and there is no dramatic clash as in the case of the red cloak.

Finally, the red horse provides a further variation. The very words put us in another atmosphere. The impossibility of a red horse demands an unreal world. It is possible that this combination of colour and form will appeal as a freak—a purely superficial and non-artistic appeal—or as a hint of a fairy-story [1]—once more a non-artistic appeal. To set this red horse in a careful naturalistic landscape would create such a discord as to produce no appeal and no coherence. The need for coherence is the essential of harmony—whether founded on conventional discord or concord. The new harmony demands that the inner value of a picture should remain unified whatever the variations or contrasts of outward form or colour. The elements of the new art are to be found, therefore, in the inner and not the outer qualities of nature.

The spectator is too ready to look for a meaning in a picture—i.e., some outward connection between its various parts. Our materialistic age has produced a type of spectator or "connoisseur," who is not content to put himself opposite a picture and let it say its own message. Instead

[1] An incomplete fairy story works on the mind as does a cinematograph film.

of allowing the inner value of the picture to work, he worries himself in looking for " closeness to nature," or " temperament," or " handling," or " tonality," or " perspective," or what not. His eye does not probe the outer expression to arrive at the inner meaning. In a conversation with an interesting person, we endeavour to get at his fundamental ideas and feelings. We do not bother about the words he uses, nor the spelling of those words, nor the breath necessary for speaking them, nor the movements of his tongue and lips, nor the psychological working on our brain, nor the physical sound in our ear, nor the physiological effect on our nerves. We realize that these things, though interesting and important, are not the main things of the moment, but that the meaning and idea is what concerns us. We should have the same feeling when confronted with a work of art. When this becomes general the artist will be able to dispense with natural form and colour and speak in purely artistic language.

To return to the combination of colour and form, there is another possibility which should be noted. Non-naturalistic objects in a picture may have a " literary " appeal, and the whole picture may have the working of a fable. The spectator is put in an atmosphere which does

not disturb him because he accepts it as fabulous, and in which he tries to trace the story and undergoes more or less the various appeals of colour. But the pure inner working of colour is impossible; the outward idea has the mastery still. For the spectator has only exchanged a blind reality for a blind dreamland, where the truth of inner feeling cannot be felt.

We must find, therefore, a form of expression which excludes the fable and yet does not restrict the free working of colour in any way. The forms, movement, and colours which we borrow from nature must produce no outward effect nor be associated with external objects. The more obvious is the separation from nature, the more likely is the inner meaning to be pure and unhampered.

* *

*

The tendency of a work of art may be very simple, but provided it is not dictated by any external motive and provided it is not working to any material end, the harmony will be pure. The most ordinary action—for example, preparation for lifting a heavy weight—becomes mysterious and dramatic, when its actual purpose is not revealed. We stand and gaze fascinated, till of a sudden

the explanation bursts suddenly upon us. It is the convic-
tion that nothing mysterious can ever happen in our every-
day life that has destroyed the joy of abstract thought.
Practical considerations have ousted all else. It is with
this fact in view that the new dancing is being evolved—
as, that is to say, the only means of giving in terms of
time and space the real inner meaning of motion. The
origin of dancing is probably purely sexual. In folk-dances
we still see this element plainly. The later development
of dancing as a religious ceremony joins itself to the
preceding element and the two together take artistic form
and emerge as the ballet.

The ballet at the present time is in a state of chaos
owing to this double origin. Its external motives—the
expression of love and fear, etc.—are too material and
naïve for the abstract ideas of the future. In the search
for more subtle expression, our modern reformers have
looked to the past for help. Isadora Duncan has forged a
link between the Greek dancing and that of the future.
In this she is working on parallel lines to the painters who
are looking for inspiration from the primitives.[1] In dance

[1] Kandinsky's example of Isadora Duncan is not perhaps perfectly
chosen. This famous dancer founds her art mainly upon a study of Greek
vases and not necessarily of the primitive period. Her aims are distinctly

as in painting this is only a stage of transition. In dancing as in painting we are on the threshold of the art of the future. The same rules must be applied in both cases. Conventional beauty must go by the board and the literary element of " story-telling " or " anecdote " must be abandoned as useless. Both arts must learn from music that every harmony and every discord which springs from the inner spirit is beautiful, but that it is essential that they should spring from the inner spirit and from that alone.

<div align="center">* *
*</div>

The achievement of the dance-art of the future will

towards what Kandinsky calls "conventional beauty," and what is perhaps more important, her movements are not dictated solely by the " inner harmony," but largely by conscious outward imitation of Greek attitudes. Either Nijinsky's later ballets: " Le Sacre du Printemps," " L'Après-midi d'un Faune," " Jeux," or the idea actuating the Jacques Dalcroze system of Eurhythmics seem to fall more into line with Kandinsky's artistic forecast. In the first case " conventional beauty " has been abandoned, to the dismay of numbers of writers and spectators, and a definite return has been made to primitive angles and abruptness. In the second case motion and dance are brought out of the souls of the pupils, truly spontaneous, at the call of the " inner harmony." Indeed a comparison between Isadora Duncan and M. Dalcroze is a comparison between the " naturalist " and " symbolist " ideals in art which were outlined in the introduction to this book.—M. T. H. S.

Kandinsky. Composition No. 2 (1910)

make possible the first ebullition of the art of spiritual harmony—the true stage composition.

The composition for the new theatre will consist of these three elements:

(1) Musical movement
(2) Pictorial movement
(3) Physical movement

and these three, properly combined, make up the spiritual movement, which is the working of the inner harmony. They will be interwoven in harmony and discord as are the two chief elements of painting, form and colour.

Skrjabin's attempt to intensify musical tone by corresponding use of colour, is necessarily tentative. In the perfected stage-composition the two elements are increased by the third, and endless possibilities of combination and individual use are opened up. Further, the external can be combined with the internal harmony, as Schönberg has attempted in his quartettes. It is impossible here to go further into the developments of this idea. The reader must apply the principles of painting already stated to the problem of stage-composition, and outline for himself the possibilities of the theatre of the future, founded on the immovable principle of the inner need.

* *

*

From what has been said of the combination of colour
and form, the way to the new art can be traced. This
way lies to-day between two dangers. On the one hand is
the totally arbitrary application of colour to geometrical
form—pure patterning. On the other hand is the more
naturalistic use of colour in bodily form—pure phantasy.
Either of these alternatives may in their turn be ex-
aggerated. Everything is at the artist's disposal, and the
freedom of to-day has at once its dangers and its possibilities.
We may be present at the conception of a new great
epoch,[1] or we may see the opportunity squandered in aim-
less extravagance.

That art is above nature is no new discovery.[2] New
principles do not fall from heaven, but are logically if
indirectly connected with past and future. What is im-
portant to us is the momentary position of the principle
and how best it can be used. It must not be employed
forcibly. But if the artist tunes his soul to this note, the
sound will ring in his work of itself. The "emancipation"

[1] On this question see my article "Uber die Formfrage"—in the Blaue
Reiter (Piper-Verlag, 1912). Taking the work of Henri Rousseau as a
starting point, I go on to prove that the new naturalism will not only be
equivalent to but even identical with abstraction.

[2] Cf. "Goethe," by Karl Heinemann, 1899, p. 684; also Oscar Wilde,
"De Profundis"; also Delacroix, "My Diary."

of to-day must advance on the lines of the inner need. It is hampered at present by external form, and as that is thrown aside, there arises as the aim of composition—construction. The search for constructive form has produced Cubism, in which natural form is often forcibly subjected to geometrical construction, a process which tends to hamper the abstract by the concrete and spoil the concrete by the abstract.

The harmony of the new art demands a more subtle construction than this, something that appeals less to the eye and more to the soul. This " concealed construction " may arise from an apparently fortuitous selection of forms on the canvas. Their external lack of cohesion is their internal harmony. This haphazard arrangement of forms may be the future of artistic harmony. Their fundamental relationship will finally be able to be expressed in mathematical form, but in terms irregular rather than regular.

VIII. ART AND ARTISTS

THE work of art is born of the artist in a mysterious
and secret way. From him it gains life and being.
Nor is its existence casual and inconsequent, but it has a
definite and purposeful strength, alike in its material and
spiritual life. It exists and has power to create spiritual
atmosphere; and from this inner standpoint one judges
whether it is a good work of art or a bad one. If its "form"
is bad it means that the form is too feeble in meaning to
call forth corresponding vibrations of the soul.[1] Therefore

[1] So-called "indecent" pictures are either incapable of causing vibrations
of the soul (in which case they are not art) or they are so capable. In the
latter case they are not to be spurned absolutely, even though at the same
time they gratify what nowadays we are pleased to call the "lower
bodily tastes."

a picture is not necessarily " well painted " if it possesses the " values " of which the French so constantly speak. It is only well painted if its spiritual value is complete and satisfying. " Good drawing " is drawing that cannot be altered without destruction of this inner value, quite irrespective of its correctness as anatomy, botany, or any other science. There is no question of a violation of natural form, but only of the need of the artist for such form. Similarly colours are used not because they are true to nature, but because they are necessary to the particular picture. In fact, the artist is not only justified in using, but it is his duty to use only those forms which fulfil his *own need*. Absolute freedom, whether from anatomy or anything of the kind, must be given the artist in his choice of material. Such spiritual freedom is as necessary in art as it is in life.[1]

Note, however, that blind following of scientific precept is less blameworthy than its blind and purposeless rejection. The former produces at least an imitation of material objects which may be of some use.[2] The latter is an artistic be-

[1] This freedom is man's weapon against the Philistines. It is based on the inner need.

[2] Plainly, an imitation of nature, if made by the hand of an artist, is not a pure reproduction. The voice of the soul will in some degree at least make

trayal and brings confusion in its train. The former leaves the spiritual atmosphere empty; the latter poisons it.

Painting is an art, and art is not vague production, transitory and isolated, but a power which must be directed to the improvement and refinement of the human soul— to, in fact, the raising of the spiritual triangle.

If art refrains from doing this work, a chasm remains unbridged, for no other power can take the place of art in this activity. And at times when the human soul is gaining greater strength, art will also grow in power, for the two are inextricably connected and complementary one to the other. Conversely, at those times when the soul tends to be choked by material disbelief, art becomes purposeless and talk is heard that art exists for art's sake alone.[1] Then is the bond between art and the soul, as it were, drugged into unconsciousness. The artist and the spectator drift apart, till finally the latter turns his back on the former or regards him as a juggler whose skill and dexterity are

itself heard. As contrasts one may quote a landscape of Canaletto and those sadly famous heads by Denner.—(Alte Pinakothek, Munich.)

[1] This cry "art for art's sake," is really the best ideal such an age can attain to. It is an unconscious protest against materialism, against the demand that everything should have a use and practical value. It is further proof of the indestructibility of art and of the human soul, which can never be killed but only temporarily smothered.

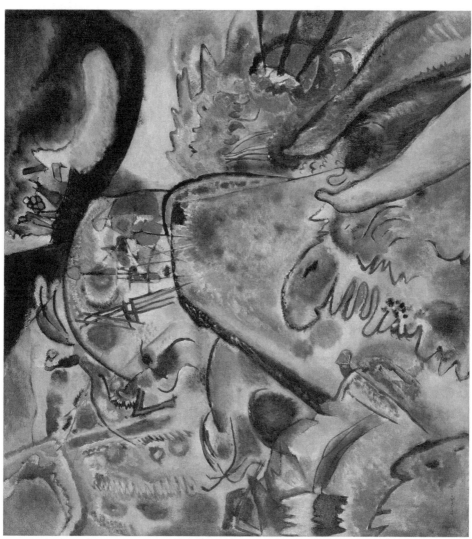

Kandinsky. "Kleine Freuden" (1913)

worthy of applause. It is very important for the artist to
gauge his position aright, to realize that he has a duty to
his art and to himself, that he is not king of the castle but
rather a servant of a nobler purpose. He must search deeply
into his own soul, develop and tend it, so that his art has
something to clothe, and does not remain a glove without
a hand.

*The artist must have something to say, for mastery over form
is not his goal but rather the adapting of form to its inner
meaning.*[1]

The artist is not born to a life of pleasure. He must not
live idle; he has a hard work to perform, and one which
often proves a cross to be borne. He must realize that his
every deed, feeling, and thought are raw but sure material
from which his work is to arise, that he is free in art but
not in life.

The artist has a triple responsibility to the non-artists:

[1] Naturally this does not mean that the artist is to instill forcibly into his
work some deliberate meaning. As has been said the generation of a work
of art is a mystery. So long as artistry exists there is no need of theory or
logic to direct the painter's action. The inner voice of the soul tells him
what form he needs, whether inside or outside nature. Every artist knows,
who works with feeling, how suddenly the right form flashes upon him.
Böcklin said that a true work of art must be like an inspiration; that actual
painting, composition, etc., are not the steps by which the artist reaches
self-expression.

(1) He must repay the talent which he has; (2) his deeds, feelings, and thoughts, as those of every man, create a spiritual atmosphere which is either pure or poisonous. (3) These deeds and thoughts are materials for his creations, which themselves exercise influence on the spiritual atmosphere. The artist is not only a king, as Peladan says, because he has great power, but also because he has great duties.

If the artist be priest of beauty, nevertheless this beauty is to be sought only according to the principle of the inner need, and can be measured only according to the size and intensity of that need.

That is beautiful which is produced by the inner need, which springs from the soul.

Maeterlinck, one of the first warriors, one of the first modern artists of the soul, says: "There is nothing on earth so curious for beauty or so absorbent of it, as a soul. For that reason few mortal souls withstand the leadership of a soul which gives to them beauty."[1]

And this property of the soul is the oil, which facilitates the slow, scarcely visible but irresistible movement of the triangle, onwards and upwards.

[1] " De la beauté intérieure."

CONCLUSION

THE first five photographs in this book show the course of constructive effort in painting. This effort falls into two divisions:

(1) Simple composition, which is regulated according to an obvious and simple form. This kind of composition I call the *melodic*.

(2) Complex composition, consisting of various forms, subjected more or less completely to a principle form. Probably the principle form may be hard to grasp outwardly, and for that reason possessed of a strong inner value. This kind of composition I call the *symphonic*.

Between the two lie various transitional forms, in which the melodic principle predominates. The history of the development is closely parallel to that of music.

If, in considering an example of melodic composition, one forgets the material aspect and probes down into the artistic reason of the whole, one finds primitive

geometrical forms or an arrangement of simple lines which help toward a common motion. This common motion is echoed by various sections and may be varied by a single line or form. Such isolated variations serve different purposes. For instance, they may act as a sudden check, or to use a musical term, a "fermata." [1] Each form which goes to make up the composition has a simple inner value, which has in its turn a melody. For this reason I call the composition melodic. By the agency of Cézanne and later of Hodler [2] this kind of composition won new life, and earned the name of "rhythmic." The limitations of the term "rhythmic" are obvious. In music and nature each manifestation has a rhythm of its own, so also in painting. In nature this rhythm is often not clear to us, because its purpose is not clear to us. We then speak of it as unrhythmic. So the terms rhythmic and unrhythmic are purely conventional, as also are harmony and discord, which have no actual existence. [3]

[1] *E.g.*, the Ravenna mosaic, which, in the main, forms a triangle. The upright figures lean proportionately to the triangle. The outstretched arm and door-curtain are the "fermate."

[2] English readers may roughly parallel Hodler with Augustus John for purposes of the argument.—M. T. H. S.

[3] As an example of plain melodic construction with a plain rhythm, Cézanne's "Bathing Women" is given in this book.

Complex rhythmic composition, with a strong flavour of the symphonic, is seen in numerous pictures and wood-cuts of the past. One might mention the work of old German masters, of the Persians, of the Japanese, the Russian icons, broadsides, etc.[1]

In nearly all these works the symphonic composition is not very closely allied to the melodic. This means that fundamentally there is a composition founded on rest and balance. The mind thinks at once of choral compositions, of Mozart and Beethoven. All these works have the solemn and regular architecture of a Gothic cathedral; they belong to the transition period.

As examples of the new symphonic composition, in which the melodic element plays a subordinate part, and that only rarely, I have added reproductions of four of my own pictures.

They represent three different sources of inspiration:

(1) A direct impression of outward nature, expressed in purely artistic form. This I call an "Impression."

(2) A largely unconscious, spontaneous expression of inner character, the non-material nature. This I call an "Improvisation."

(3) An expression of a slowly formed inner feeling,

[1] This applies to many of Hodler's pictures.

which comes to utterance only after long maturing. This I call a " Composition." In this, reason, consciousness, purpose, play an overwhelming part. But of the calculation nothing appears, only the feeling. Which kind of construction, whether conscious or unconscious, really underlies my work, the patient reader will readily understand.

Finally, I would remark that, in my opinion, we are fast approaching the time of reasoned and conscious composition, when the painter will be proud to declare his work constructive. This will be in contrast to the claim of the Impressionists that they could explain nothing, that their art came upon them by inspiration. We have before us the age of conscious creation, and this new spirit in painting is going hand in hand with the spirit of thought towards an epoch of great spiritual leaders.

APPENDIX A: PROSE POEMS

Landscape
You said the Lake was silvery? It is not silvery! It is wet.
You see, a small sheep drinks its Wet Water. It should
not drink. Not worth the Bother. There is already the Butcher with
his long, oh, long Knife. He is already looking for it. He is already finding it.
It is impossible that he should not find it. What is it still
drinking for?

Or is it *absolutely* necessary, that it drinks one last time?
That is just what you say, but you have also said that, the Lake
was silvery!

The other The Lake is silvery and the long, long
moving Clouds are wandering violet Ways in the Sky. And the great Mountains over there are sleeping
Monsters covered with old,
mouldy worn-off Skins.
And the big Silence was loud Talk.
But are Tears precious Pearls, which you are afraid of losing?

Evening
The Lamp with the green Shade says to me: Wait! Wait!
What am I supposed to wait for? I am thinking. And it says to me showing me the green: Hope!

From far away through the Cracks in the doors and through the hard Wood and hard Stone there
come to me into the Room Sounds. They are there and speak to me. Persistently and with Emphasis
they are saying something.

Sometimes I hear clearly: Purity.

A grey narrow grey-green face with long heavy Nose has
been in front of me for a long time looking at me (even if I don't see it!)
with white-grey Eyes.

Through the floor from below a dull, wooden, animal
laughter wants to Force its way in to me. Every half Minute it bumps against the Floor and is annoyed,
because it can't get in.

I bend closer to the face. It smiles. But the Eyes are quite
sleepy and dull.

I am rather Frightened of it. Overcome it however and look. Firmly
in the Eyes, which are growing perhaps continually duller.

The Sounds come and fall and stumble.

From the Church-tower Sounds also fall, like fat bursting showy
Clods. Downstairs the Neighbours are still laughing – People.

Why did you say that Word to me yesterday?

APPENDIX B: LETTERS

Unless otherwise stated all Kandinsky's letters are written from Ainmillerstr. 36/1, München and signed by the artist.

1
Wassily Kandinsky to Frank Rutter, 22 August 1911 (postcard)
Dear Sir,
I am sending you 16 small texts, about which I wrote to you. There are still some which I don't have here at the moment. At the end of the album will be printed 3 or 4 of my 'compositions for the stage'. These are small 'tableaux' consisting of gesture (movement of 'dance'), colour (movement of painting) and of sound (musical movement – this will be done by the famous composer Hartmann) on the principle of pure theatre.
 Affectionate Greetings!
TGA 8221.8.1

2
Wassily Kandinsky to MTHS, 6 October 1911
Dear Sir,
Thank you for sending me your periodical. I am very glad to give permission for the reproduction of my woodcut.
 I am very pleased that the so-called modern art movement is mirrored in your journal and meets with interest in England. Mr Brooke from Cambridge also told me about this last winter.
I enclose for you the prospectus of the art periodical that I have founded; the first issue is due to appear in January.
 Also this month my book 'Über das Geistige in der Kunst' will be published. I will send you a copy. Please write back with your impression.
 Affectionate Greetings!
 Yours sincerely

[ENC: PRINTED PROSPECTUS FOR *DER BLAUE REITER*, R. PIPER CO., MUNICH]
Towards Spring 1912 there will appear in R. Piper Co, Verlag, Munich: 'DER BLAUE REITER'. The collaborators of this organ, to appear in random order, are mainly artists (painters, musicians, poets, sculptors). From the contents of the first volume: Roger Allard, 'On the New Painting'; Franz Marc, 'Intellectual Goods'; Franz Marc, 'The "Fauves" of Germany'; Auguste Macke, 'The Masks'; David Barljik, 'The "Fauves" of Russia'; T.V. Hartmann, '"Anarchy" in Music'; Arnold Schonberg, 'The Question of Style'; Kandinsky, '"The Yellow Sound" (a stage composition)'; Kandinsky, 'On Construction in Painting'; etc. About 100 reproductions.
TGA 8221.6.18

3

Wassily Kandinsky to MTHS, 7 December 1911

Dear Sir,

Many thanks for your letter. It will give me great pleasure to make the acquaintance of your cousin. The texts have no connection with the woodcuts. I wrote them because I could not express these particular feelings by painting. There is however, as you will certainly have noticed yourself, a deep *inner* relationship between the texts and the woodcuts. And indeed even an outer one: I treat the word, the sentence in a very similar way to that in which I treat the line, the spot.

The great inner relationship of all arts is coming gradually ever more clearly to light. That is a great joy to me and I am happy that here too I can contribute somewhat.

Read my texts without looking for an explicit narration. Just let them work on your feeling, on your soul. And I think they will become clear to you. If this should really be the case, please write to me about it.

With Affectionate Greetings!

Yours respectfully

TGA 8221.6.19

4

Wassily Kandinsky to MTHS, 13 August 1912
Murnau, Oberbayern

Dear Mr Sadler,

As you can see I am at the moment in the country. After a serious illness I am not allowed to travel much for the time being and for that reason am not able, much to my regret, to come to Munich. It would give me *very* great pleasure, however, if you and your father would visit me here. You would only lose half a day, and you will see something of the surroundings of Munich. I would recommend the S-train at 2.30, with which you will be here at 4.00. At 8.17 you have a good E-train, with which you can be back in Munich at 9.22, or the 10.05 train, which gets to Munich at 11.54.

Would you be so kind as to telegraph to let me know on which day you could come (i.e. on the 16th or the 17th?) that is of course if you are able and willing to come. I would then pick you up from the train, as I am not so easy to find here.

In anticipation of your agreement.

With Affectionate Greetings!

Yours

TGA 8221.6.20

5

Wassily Kandinsky to MTHS, 30 September 1912

Dear Mr Sadler,

I am happy to let you have priority in the translation for one year, i.e. until 1 October 1913 the translation rights belong to you. As far as the terms/conditions are concerned, I would prefer to sell not only for the first English edition, but also for all future ones at the same time. I can probably assume that the book will also be successful in England, and later America. In Germany the second edition, which was necessary after scarcely 3 months (2,000 copies), is also selling very well, and indeed outside Germany, in Austria, Switzerland and even Holland. It won't be long now before the 'new' art quite definitely reaches America – then the sale of the book there is assured. I spoke today with an experienced bookseller and he advised me to ask 1000 marks for the translation rights, and that's what I want to do. I can tell *you* in confidence that I would come down to 800, but of course not willingly. But I am naming the price limit straight away so that we can save ourselves the correspondence. It must be borne in mind that this book matured in me for 10 years and that I have re-written it 3 times before it was published here. Piper did not buy the translation rights from me, they belong to me, and he has nothing to say in the matter. One could *possibly* supplement the book in English with my article in the 'Blaue Reiter' about the question of form,

if the B.R. should not find a publisher. Otherwise for the English version I would somewhat extend/expand the chapter 'Language of Form and Colour' – *perhaps* even fundamentally. I have had more thoughts on the subject this summer, although these naturally grew out of the earlier ones. In this last case I would not sell for less than 1,000 marks. You have the book after all in the *2nd* edition, which is authoritative for the translation?

Forgive me for not writing French, I am forgetting it more and more and after all, you speak excellent German. In about 8 days I am going to Russia for 6–8 weeks. If you reply after 10.x then please write to *Odessa* (South Russia), Skobelewstrasse 12, c/o Mr Kojevnikoff. I will send you further addresses. But in any case my letters will be forwarded. How are you? And your father? Did he ever get his fountain pen back?

I have had a tour of my exhibition arranged. I am sending you a catalogue, and also one to your father.

We both send our affectionate greetings and will be very happy to hear from you.

Yours

TGA 8221.6.21

6
Wassily Kandinsky to MTHS, 8 December 1912
Moscow

Dear Mr Sadler,

Thank you very much for your letter, which I have just received. Unfortunately I didn't get the previous letter.

This time I only hasten to let you know that I agree to 500 marks for the translation rights to the first edition. What I actually put the most emphasis on is that my ideas should receive wider circulation. The financial side is a secondary consideration. If Piper causes me trouble with the plates [i.e. printing plates], I'll send you new ones. Have you got my book in the 2nd edition? It is authoritative for the translation. If you *don't* have the 2nd edition, then I'll send you one from Munich where I am returning any day now.

With affectionate greetings!

Yours,

P.S. *Perhaps* (entirely *between ourselves*!) a largish exhibition of 'new' art will be going to America as soon as the spring of 1913, where I too will be represented. That would be a good sales opportunity. *My* collection (which is now in Holland) is to be exhibited in London on April 13. It would be splendid if the book could appear in English by then.

TGA 8221.6.22

7
Wassily Kandinsky to MTHS, 20 December 1912
[Munich?]

Dear Mr Sadler,

Thank you very much for your letter, which I received here and have unfortunately so skilfully put away that I couldn't find it again. So, I ask you to fill in the name of the firm yourself in the enclosed document for which I thank you very much in advance. I have come across various tasks here, which I have to deal with quickly, so I must be brief.

With affectionate greetings!

Yours sincerely

TGA 8221.6.23

8
Wassily Kandinsky to MTHS, 23 February 1913

Dear Mr Sadler,

Would you be so good as to let me know if and when you need the printing-plates and blocks for woodcuts for the translation of the 'Spiritual'. I am presently negotiating for a translation into Dutch. So, maybe, I could order electrotypes for both translations at the same time. I shall be very grateful

to you for the information.

How are you and your father?

As far as I am concerned I am only now somewhat recovering since my Russian journey. I had to endure so many visits, all sorts of events that I scarcely managed even to work. Now, fortunately, it has become much quieter, and I am working with delight. There is after all nothing better than real work! I am immersing myself more and more in the secrets of the delicate balance, the veiled combinations, in the discrete co-existence of individual elements, which form that which is called a picture.

My book 'Sounds' has appeared and I gave the publisher instructions to send you an author's copy. Have you had it? Piper has miscalculated the number of author's copies and is now being stingy with them.

Munter and I send affectionate greetings to you and your father.

Yours

TGA 8221.6.24

9

Wassily Kandinsky to MES, 24 February 1913

Dear honoured Professor,

Many thanks for your letter. You are completely right, and over time one gets such a thick skin that such stabs from the critics don't reach the flesh. But if only for reasons of principle it cannot be denied that from time to time criticism has to be chastised without mercy. I am happy every time that people themselves (i.e. without help and compulsion of a more or less official organisation) unite for a more ideal, as well as material, cause and together, of their own free will, undertake to do something. Here [in Munich] too this is the only thing which gives me pleasure if, as I have said, I don't want to, and cannot, deny the benefit of the undertaking. Walden has accepted my art with such burning interest that I can only thank him also for his general protest.

We would both be very happy if you would visit us this summer again and hope very much that you will give us this pleasure.

With affectionate greetings from us both,

Yours sincerely

TGA 8221.2.49

10

Wassily Kandinsky to MTHS, 9 April 1913 (postcard)

Dear Mr Sadler,

Since, as I hear, Piper is causing you difficulties with the electrotypes (payment in advance), I have therefore ordered the electrotypes from him *on my authority*, and asked him to send you the electrotypes as soon as possible. It is a nuisance to have to deal with him – one ruins one's nerves. I am very pleased that the translation is soon coming out; hope you liked 'Sounds' so far.

With affectionate greetings!

Yours

TGA 8221.6.25

11

Wassily Kandinsky to MTHS, 10 April 1913

Dear Mr Sadler,

Thank you very much for the book. Up to now I have only been able to flick through it a bit. The problem itself is of great *theoretical* importance and will eventually certainly be of use to monumental *Art*. But *now* this question has become much more complicated by the fact that music is making every effort to reject the tempered instrument (it would actually be more accurate to say the tempered scale). Russian musicians specifically are much occupied with this. The result of this revolution can still not be guessed at all. But they will be wonderful.

I have heard via Piper that you want to change the format of my book and therefore can't use our electrotypes. Is this change absolutely necessary? At the time, I chose with great love precisely this format, paper, typeface, etc. Editions 2 and 3 turned out completely as I wished (in the first edition the page ('*mirror*' as it is called) is too big). Apart from purely artistic reasons, I chose the square format so that the reader is not forced to turn the book in order to see the reproductions properly. Apart from that, the book must not appear too thin. It is funny, but the reader is *absolutely* influenced by the *thickness* of the book. He shouldn't get the impression of a little brochure.

Your letter of Apr 9 has just arrived. So, of course I am quite happy to give you the reproduction rights, which are included in the 500 marks. I am just afraid that reproductions, which are made from other reproductions, become unclear and opaque. Electrotypes are surely better, it seems to me. But I won't lecture you. I just hope that the pictures will be flawless, don't you agree? You will surely also use all the woodcuts, which decorate the chapters (and the *title-page*). These are not drawings after all, but woodcuts directly printed from the wood-printing block, which I engraved. Electrotypes (but zinc blocks too) are just as good as these wood blocks.

You will surely also include the first and second *foreword* and the dedication to Elisabeth Tichieff. It would be quite the greatest delight for me if the English edition were to be *completely* the same as the 2nd or 3rd German edition. You will make the translation, not from the 1st edition, but from the 2nd or 3rd, won't you? The latter two are completely the same. Are bound copies also being produced? These turned out very nicely with Piper. For advertising purposes a very good fact to use is that in Germany the book went through three editions in less than *one* year.

The Dutch translation was delayed by a death and won't be in print till the Autumn. Perhaps then the Dutch will buy the blocks or electrotypes off you – please excuse all these questions! I would naturally like the book, even in English (England and America!) to take a form, which corresponds as much as possible to my taste. Many thanks in advance and affectionate greetings!

Yours

TGA 8221.6.26

12
Wassily Kandinsky to MTHS, 25 April 1913
Dear Mr Sadler,

Many thanks for your letter. I am very pleased that the book is being produced in this form.

Would you be so kind as to give me some advice. I have received a card from the Allied Artists' Association with the remark that they would welcome my participation in their exhibition. I would be glad to send a couple of pictures, but with the expenses: carriage, fees, etc.! the whole thing comes to *c*.100 marks and the possibility of sales is after all very small. I would possibly decide in favour after all, but only in the event that *these* exhibitions are really seen and appreciated. I should be very grateful to you if you could let me know your opinion on the whole question. I must regrettably add that the matter is rather urgent.

With affectionate greetings!

Yours sincerely

TGA 8221.6.27

13
Wassily Kandinsky to MTHS, 25 July 1913 (postcard)
Moscow

Dear Mr Sadler, might I ask you to send the number of 'Rhythm' with your article about my book and me to my Moscow publisher? The address is Herr Angert, Moscow, Nikitsky Bulwar 7, kw. 5. I would be very grateful to you. My address until the end of August is: Moscow, Neopalimowsky 5. Affectionate Greetings!

Yours

TGA 8221.6.28

14
Wassily Kandinsky to MTHS, 30 July 1913
Neopalimowsky, 5, chez Dr Kojevnikoff, Moscow
Dear Mr Sadler,
Your letter of the 24th inst. was forwarded to me here. I wrote immediately to Piper: 1) asked him that he should send you the original wood blocks of my woodcuts in the book – I think it best if you order the electrotypes from them yourself; 2) I asked him to determine the minimum price of the electrotypes from the 8 pictures.

As you can see, I am in Moscow and not able to do much. Unfortunately, I wouldn't be able to send you any photos, even in an emergency, before the beginning of September! But perhaps I could have these photos found in my flat in Munich and sent to you, that is, only those of my pictures. You could, perhaps, order the others (Raphael, etc) from J. Littauer (Art Salon, Odeonsplatz, Munich). They cost about 1 mark, I believe ('carbon print'). Cezanne costs 15 francs at Druet's *with* rights for reproduction. It is a large beautiful photograph.

For *my* pictures I ask no payment from you, i.e., I am letting you have the reproduction for nothing.
[PASSAGE DELETED:]
In London it seems I have sold 2 pictures, though very cheaply. So, at any rate I have covered the carriage and other costs. Could you not find out at the AAA the names of the purchasers? 'Der Sturm' is publishing early in the autumn an album with *c.*60 of my pictures and 4 articles about me. I would be happy to mention 2 in private ownership in London. I would also like to include the watercolour in your possession, with your name as owner. Could you possibly send a photo (13 × 18) to 'Der Sturm', Ed. Herwarth Walden. Address: Berlin w9, Potsdamerstr 134A. I would be very much obliged to you! Please also forgive my haste: I am wearing myself out in Moscow.

Affectionate Greetings!
Yours
TGA 8221.6.29

15
Wassily Kandinsky to MTHS, 7 August 1913 (postcard)
Moscow
Dear Mr Sadler in haste!
Piper is willing to let you have the blocks for 150 marks, i.e. for 6 pfennigs, instead of for 240 marks. That will probably be all right with you, won't it? A difference of 90 marks! These dear German publishers! Please write to not only to Piper but also to me whether you agree. Affectionate Greetings!
Yours
[SIGNATURE]
Do you not know who bought my pictures?
TGA 8221.6.30

16
Wassily Kandinsky to MTHS, 4 October 1913
Dear Mr Sadler,
I haven't been hearing anything from you for a long time now. Is the book coming out soon? Would it be possible to make a change in the choice of pictures? If it were possible I would be very glad. The costs would after all be very low, since the printing-blocks belong to me and I would let you have electrotypes at cost price.

The change is for the following reasons:
1. The newly selected pictures are much more typical,
2. more varied and

3. are to be found in private ownership, which could have good practical consequences.

I would exchange Impression 4 for *Impression 2* (Koehler collection, Berlin), Improvisation 18 for *Impr. 29* (A. J. Eddy collection, Chicago) and add a more recent picture of mine 'Little Joys' (Beffie collection, Amsterdam). So only Composition 2 would remain. I would even exchange the 2 first electrotypes with you, i.e., I'll send you Impres. 2 and Improv. 29 (electrotypes) for nothing and you'll send to 'Der Sturm' the electrotypes of Impres. 4 and Improv. 18. So you would only have to pay for 'Little Joys'.

Please reply *by return* – by telegraph if possible (only one word 'agreed') and I will order the electrotypes immediately. You'll then send your electrotypes, also by return, to Herr Herwarth *Walden*, Verlag 'Der Sturm', Berlin w9, Potsdamerstr. 134A. In haste!

Affectionate Greetings!

Yours

TGA 8221.6.31

17
Wassily Kandinsky to MES, 22 October 1913
Dear Professor

Would you have the great kindness to give me news concerning your son? I hope he is not ill. But perhaps he is away or is living somewhere else: I have had no reply to my urgent and important letter and neither has Herr Angert, my Russian publisher, who has written to your son about the blocks of the 'Spiritual'. I am so used to receiving quick and exact replies from your son, that I cannot explain his silence to myself.

Please excuse the trouble I am causing you, and accept my thanks for it in advance.

Sincerely and respectfully

TGA 8221.2.51

18
Wassily Kandinsky to MES, 29 October 1913
Dear Professor

Thank you very much for your letter! Today I also got a letter from your son, from Boston, in reply to mine. He has given appropriate instructions to London – so everything is sorted out.

It is always a pleasure for me to hear that you still enjoy my things. It lies in your power to increase my pleasure significantly! Would you permit me to dedicate a sketch, a watercolour or something of the sort to you? I hope very much that you will not turn down this request, and will wait for your answer with hope and impatience.

I cannot understand at all how pictures by me could get to Manchester. But one experiences such surprises sometimes.

With affectionate greetings, and from Frau Munter too.

Yours most respectfully

TGA 8221.2.52

19
Wassily Kandinsky to MES, 10 November 1913
Dear and respected Professor,

Thank you very much for your letter. 'Dedicate' ['Dedizieren'] means, properly translated, 'dedicate' ['widmen'], but in reality means 'give'. The main thing however is that you allow me to send you a work of mine – that will give me great pleasure, and [I] will select something not too large (I don't know if you have much hanging space!), but really good and characteristic of mine. I am working now on a large picture ('Composition 7') and have among the sketches a good thing which it is true is only a fragment of the large picture, nevertheless has an independent value. Something like that

would, I think, be a good choice.

It is a great joy to me to know that in you and your son, I know friends of my art in a distant country. And the number of my friends is by no means great.

We both send very affectionate greetings,

Yours most respectfully

[DELETED PASSAGE:] Of the 'deux cliches', Piper has apparently lost one. I have had it ordered and sent (to Constable) at my own expense. Otherwise everything is in order. Excuse me! I have got the letters the wrong way round: I meant to write about Piper to your son.
TGA 8221.2.53

20
Wassily Kandinsky to MTHS, 10 November 1913
Dear Mr Sadler,

Thank you for your letter. I have also heard from Constable: the change is still possible. So, I have quickly ordered the electrotypes and they have already gone off. I hope therefore that everything will be put right. I am very curious about the English book. Presumably, the publisher will also produce good advertising. And in America too? I know only two people there who are interested in my art: in New York Mr Alfred Stieglitz (291 Fifth Ave, City) and Mr Arthur J. Eddy in Chicago (800 The Temple). Both have new pictures by me, Mr Eddy indeed many and from nearly all my periods. He himself is writing a book about the new art, which is appearing in the winter. His picture collection is apparently very interesting.

How are you getting on in America? Are you content? It must surely be a completely different country from what we are used to here. But many customs, as far as I have heard, are similar to those of Russia. The way of thinking, however, is, I believe, very different.

Affectionate greetings from the two of us, and much success and good luck!
[SIGNATURE]

Piper has apparently lost one of the 'deux clichés'. I have ordered a new one at my own expense and had it sent to Constable. Otherwise everything is in order.
TGA 8221.6.32

21
Wassily Kandinsky to MTHS, 24 December 1913
Dear Mr Sadler,

Thank you very much for your comprehensive letter. I was very interested in the piece from the article in 'Camera Work'. In Moscow a little book about me is being done by my publisher (portrait, small autobiography, some fairly long articles about me, list of owners and collections where my pictures are to be found and finally German, Dutch, English critiques for and against me) where probably (if it is not too late) the excerpt you sent will also be reprinted. This little book has to introduce me to the general public in Russia, where I have rarely exhibited anything, and even then, not very much. I find this idea very inspired. The same publishing house has also undertaken the publication of the 'Spiritual' and the book, which just appeared in Berlin (1901–1913)*. The 'Spiritual' I have enlarged somewhat and 'dotted the i's and crossed the t's' in many places. If therefore this book were to be published in America, I would very much like to include what I have done for the Russian edition.

I have asked Constable to send me 20 or so copies of my book (the German publishers supply 40). Would you perhaps ask the publishers, when the book appears, to send me my fee? I would be very grateful to you. I would of course be very pleased if the Mifflin Company were to publish the 'Spiritual'.

We both heard with great pleasure that you are getting married! Many very heartfelt congratulations and please give my respects, although I don't know her, to your intended. Perhaps

you will come sometime to Munich together, which would make us very happy. And from here Russia is not far any more: one can get to Moscow comfortably in 2 days, where I'll ask my friends to show you everything of interest. Very many Germans, English and other nationalities too go to Russia now. On my last trip I heard a lot of English in Moscow, and that was in fact not in a touring season.

[It is] remarkable that a dream of mine often recurs: I am leaving the ship and disembarking in New York – but there is nothing there but little grey houses.

Don't forget us entirely, and do write, even if not on business!

Once again, affectionate greetings and much success in everything.

Yours,

[SIGNATURE]

* which you have probably already received: I have sent you a copy.

TGA 8221.6.33

22
Wassily Kandinsky to MES, 6 April 1914
Dear and respected Professor,

I don't know if your son has already returned to England, so permit myself, therefore, to address myself to you with a question.

Do you know if Constable has published my 'Geistiges' yet? As long ago as autumn, it was hurried through with the photographs, so that I could assume that the book was to appear within a few weeks. But since then, several months have already gone by and I have heard nothing of the book.

I asked Messrs Constable in December to send me my author's copies (I was willing to be satisfied with 20), but received neither the books nor an answer to my letter. It was also agreed that I should receive a fee of 500 marks, which to my regret is still outstanding. My finances don't look very pretty at the moment and this sum, though not large, would be *very* welcome to me.

Please forgive me for dragging you into these matters. I thought that perhaps you would be so amiable as to tell your son of my worries when he is home again. For quite a long time I have postponed this request. Now there is no other alternative – I *have* to do it.

Today I received the book by Arthur J. Eddy (Chicago) – 'Artists and Post-Impressionism', which at first sight seems interesting and well done. Many good reproductions (that is, the colour ones at the height of modern technique, which is not yet very advanced), comprehensive text, large bibliography, etc. Certainly it will make a strong impression in America and have the effect of surprise like a bomb. The design is beautiful and serious. Unfortunately, I only understand English with difficulty and too often very inadequately. I always regret that in my youth I gave up the English lessons I had already begun. If only I could at least speak English as much as I can read French! That is to say, not much, but nevertheless adequate for reading. Now it is difficult to repair the omission: I must deal economically with time.

Once again I beg your pardon for the worry I am causing you and send you greetings with sincere respect and affection from us both. Please also send our greetings most truly to your son.

Yours most respectfully

TGA 8221.2.54

23
Wassily Kandinsky to MTHS, 16 June 1914
Murnau, Oberbayern

Dear Mr Sadler,

I thought you were on your honeymoon! I have just written to the Mifflin Co. and asked for an alteration of two sentences in the 'Spiritual', or if *that's* not possible, then for the insertion of a slip (errata) with the correction of these sentences. I also enclose them for you.

Corrections:

English *Page 7*:

it says: Shapeless emotions such as fear, joy, grief, etc

it *should be*: Coarse and precise emotions etc

(i.e. directly: coarse and *precise* emotions should *not* in my opinion contribute to the content of works, *but rather*, just those imprecise, somewhat refined ones which one cannot put a name to)

and *Page 34*:

Debussy has had a great influence etc.

is not right, but it should be the *opposite way round*:

Debussy has been greatly influenced by Russian music, notably by Mussorgsky.

As far as the Georgian drawings are concerned, I hardly think think that many people would be interested. In any case I enclose a short list with addresses [separate sheet with 25 names and addresses], to which it would be good to send prospectuses. I myself unfortunately am stuck this year with very slender resources! I even have to look energetically for opportunities to sell pictures, even if cheaply. My personal financial crisis coincided this year unfortunately with the general crisis in Germany (you've surely read about the famous Defence Tax! [an Army Tax]). I would gladly now (even if unwillingly) dispose of the pictures, which I have now exhibited at the AAA for half the price, or still less. Do you by any chance know anyone who would be interested in them? Mr Eddy (have you read his book?) obtained a commission in New York for me, which has helped me financially to some extent. Nevertheless, I must keep looking! Without boasting, I can say quite objectively that the purchaser would be investing his money well. You know of course that I am not counting you among these purchasers, don't you? It would be very embarrassing to me if you were to understand (= misunderstand) my request in that way. On the occasion of the great event in your life I have long wanted to ask your permission to send you a small picture by me. I have just now been able to pick out one of the sketches for the Americ[an] commission for this purpose. I hope you will not turn it down. It is a constant joy to me to know [that there are] such friends of my art in distant England as yourself and your father.

Many affectionate greetings from us to yourself and although we don't know her, to your wife.

Yours

TGA 8221.6.34

24
Wassily Kandinsky to MTHS, 14 October 1914
'Mariahalde', Goldach, St Gallen, Switzerland

Dear Mr Sadler,

Here I am in Switzerland where I have to spend the frightful time of the war. I would gladly be in Russia but the means of getting there were not pleasant. Would you have the great kindness to do me a service. I was sent from Moscow, the sum of £100 via London and via the Schweizer Bankverein. I think that the order from Moscow was given to the Tea Co., *K and C. (S.) Popoff,* in London, as my brother-in-law is one of the directors of that company in Moscow. And now it has been 3 weeks that I have been waiting for this sum without success! Could you ask over the telephone what the cause of this delay is? I would be most obliged to you. As I was told today at the Schweizer Bankverein here, the mail with England is now once again in order: a letter takes 3 days.

What do you say about such a tragic time? How happy I would be if this battle were a spiritual battle and not [one] of guns. But the causes are deep seated. And so will the effects be also. Perhaps this bloody red line was necessary to divide what is to come, from the past.

What are you doing? and your father? your family? I would be very happy to have news of you.

Mme Munter and myself send warm greetings to you and your wife,

[SIGNATURE]

[ANNOTATED: CJ POPOFF, 21 MINCING LANE, CENT 13187]

TGA 8221.6.35

25

Wassily Kandinsky to MES, 8 November 1914
['Mariahalde'], Goldach, St Gallen, Switzerland
Dear Sir,
Thank you very much for your letter. It is more than a pleasure to receive news of people allied inwardly in this sad and black time.

It is besides always a joy for me to hear such things about my painting as you say in your letter. I doubt whether it was the war which inspired me in my drawings. I feel another battle much more important, of which this war is merely a material phase. This battle of which I am speaking is a struggle between two worlds – the age, almost ended, of the 19th century and that of the Future. I have been aware of this struggle for years. My hope is to reach an equilibrium of my soul, which will give me the possibility of creating positive harmony, vintrice (vintrix). Unfortunately I express myself very clumsily in French! But I hope that you will understand me. Almost all my life I was seeking to give strong expression to this struggle, which I *understood* only a few years ago. What I would still like to attain is to place myself *above* the struggle and to find within myself definitive harmony. *Only* in this last case would I be able to find it in painting.

With best wishes
TGA 8221.2.55

26

Wassily Kandinsky to MES, 22 October 1936
135, Bd de la Seine, Neuilly s/Seine (Seine), France
Very dear and respected Professor,
I was very pleased to get your note.
I was only sorry that you had to have an accident in Paris and that because of that you were unable to call me. But it is very fortunate that your accident has not led to bad consequences. I am very glad about that.

A pity that you come so rarely to Paris! It would be so nice to meet you again after 23 or 24 years. Statistically, a whole 'generation' from the lovely time when you visited me in Murnau. How everything has changed in Germany since then! All my pictures have been taken down in German museums, with the exception of the museum in Halle/Saale where everything remains untouched, and where a room with my watercolours still exists today.

It will perhaps interest you that just recently in the foreign press and also in German papers very much has been written about the fact that the museum in Essen (Folkwang Museum) has sold a pre-war picture by me to a Berlin art dealer for 9,000 marks. The art dealer has definitely acquired the picture under commission from a foreign collector. This case made me happy, because a good picture by me was finally taken out of the cellar and was allowed to see the light again. However, the case in and of itself is highly peculiar, particularly because this collection was bequeathed to the museum by a collector on condition that all the pictures should be hung and that none of them could be sold. The deceased collector was called Orthaus, and was one of the first brave German collectors who began to acquire new art several years before the war. Now, however, the Director of the Essen Museum suggests that all modern pictures should be requestrated out of *private* collections, so that German youth is not corrupted by this 'Communist and Marxist' art. Be glad that you're English, where such suggestions are scarcely possible. I think at that of many German collectors, who also own my pictures, some of whom I know personally, and are probably now scarcely in a cheerful frame of mind. Let us hope that the 'energetic' plan of the Museum Director does not become reality.

From time to time my English visitors tell me with enthusiasm of your collection. I knew too that you moved to Oxford where you apparently feel very comfortable. it would be a great pleasure to me to make the acquaintance of your wife, and I hope that you both come to Paris again soon.

Life is very pleasant here, although politics is too much talked about. I am no politician, and such conversations mean little to me, and thus bore me considerably. I avoid them as well with fairly good

success. Unfortunately people today are so taken up with politics that there is neither time nor space for poor art. I am glad however that England is at least showing a lot of interest in new art – many exhibitions, always new art galleries, periodicals, etc.

I still remember very vividly my conversation with your son when he visited me with you. I asked him, on that occasion, whether there was any new art in England and whether the English public was at all interested in new art. He replied 'We English are slow; wait another 25 years and then there will be'. And then he added, 'We're slow but, on the other hand, not fickle; if we get interested in something then it's not over and done in an in instant, but very enduring'.

As I now see, your son was completely right: after, in actual fact, 25 years, the interest in England has appeared and how! I believe you were one of the very first 'swallows' in this regard. But as they say, 'One swallow doesn't make a summer'. So this summer has taken rather a long time.

Do you know how the Russians say 'the slower you travel, the further you get'? It doesn't mean that one should harness tortoises to one's cart. It means only that every development must have time. I personally prefer a rather slower development to a too rapid one. Or as an Academy professor in St. Petersburg once said to his pupils, 'The artist must not be slow, but he must not hurry either – he must *hurry slowly*'. Don't you find that splendid?

Now I hope that you still command the German language as well as you did earlier, and that reading my German letter will not be too boring for you.

I send my warmest greetings and please give my regards to your wife. My wife [Nina], although unknown [to you] joins me in my good wishes.

Yours

TGA 8221.2.75

NOTES

This text is based on an article by the author, 'Blue Spiritual Sounds: Kandinsky and the Sadlers, 1911–16', first published in the *Burlington Magazine*, September 1997, vol.139, no.1134, pp.600–15, where the full transcripts of the relevant correspondence between Kandinsky and the Sadlers are given in their original language.

For their encouragement and support, I would like to thank Beth Houghton, Sue Breakell (Library & Archive, Tate); Roger Thorp, Nicola Bion and Sarah Derry (Tate Enterprises); with special thanks to Ilse Holzinger for kind permission to quote from correspondence in the Gabriele Münter und Johannes Eichner Stiftung, Munich; Christian Derouet, Societé Kandinsky, Centre Georges Pompidou, Paris for his most generous permission to publish Kandinsky's correspondence and texts in full; Konrad Moritz Heistermann for expertly translating and transcribing Kandinsky's letters and texts in German; Marlene Burston for ably checking my French translations and transcripts; and Persephone Collings to whom this book is dedicated with love.

1 Earlier versions in English had appeared, such as *The Elements of Architecture* by Sir Henry Wooton in 1624, but this was a freer adaptation rather than a full translation, while a later attempt in 1692 was much abbreviated.

2 Giorgio Vasari, *Lives of the Most Eminent Italian Painters, Sculptors and Architects*, translated by Gaston Du C. De Vere and published as 10 vols., London 1912–14.

3 Sir Michael Ernest Sadler (1861–1943) (MES) was Professor of the History and Administration of Education, Manchester University, 1903–11, Vice-Chancellor of Leeds University, 1911–23 and finally Master of University College, Oxford, 1923–34. His son, Michael T. H. Sadler (1888–1957) (MTHS) became a successful novelist (*Fanny by Gaslight*, London 1940), publisher and bibliographer. In addition to translating Kandinsky's *Über das Geistige in der Kunst*, he wrote a biography of his father, *Michael Ernest Sadler 1861–1943: A Memoir by his Son Michael Sadleir*, published in London in 1949. Sir Michael Sadler began to collect art on a modest scale in 1892, when he created a 'fund' into which were paid any extra earnings for purchases of English watercolours and items of furniture. However, it was not until 1909, whilst on holiday with his son in the Netherlands, that his taste broadened and he began

to collect on a much larger scale. Indeed, his son was influential in these early years, and with his support, his father began to turn his attention increasingly to contemporary work, supporting many younger British artists, notably Mark Gertler, Henry Moore, John and Paul Nash, John Piper and Stanley Spencer. In addition, he became increasingly interested in the 'new' or 'modern' art emanating from Europe, and in particular in the work of Wassily Kandinsky. The Sadler papers (TGA 8221) were purchased by the Tate Gallery Archive in 1982 and catalogued by the author in 1993.

4 Wassily Kandinsky, *Über das Geistige in der Kunst*, Munich 1912; translated into English by MTHS as, *The Art of Spiritual Harmony*, London and Boston 1914, but known later as *Concerning the Spiritual in Art*. In his letters Kandinsky often simply refers to the book as the 'Spiritual'. Though opaque in places, *Concerning the Spiritual in Art* summarises Kandinsky's ideas and experiences during the first decade of his artistic activity and encompasses topics from colour theory to theosophy.

5 Overall, the Sadler papers contain fifty-three letters and cards to and from Kandinsky: twenty-five to MTHS, 6 October 1911 – 29 August 1923 (TGA 8221.6.18–42) and twenty-seven to and from MES, 24 February 1913 – 22 October 1936 (TGA 8221.2.49–75).

6 Wassily Kandinsky, *Punkt und Linie zu Fläche*, Bauhaus, Dessau 1926.

7 This would tie in with what is known of Kandinsky's circumstances at this time. In late 1898, he had completed two years of study with Anton Azbé. As a next step in his art education, Kandinsky hoped to enrol with the Secessionist, Franz von Stuck. However, Stuck turned him away and suggested that he spend a year in a drawing class at the Munich Academy. Unfortunately, Kandinsky failed the Academy's entrance exam and so spent much of 1899 working independently. This year of contemplation and reflection may have given Kandinsky an ideal opportunity to put pen to paper.

8 As detailed by Lindsay and Vergo (eds.), *Kandinsky: Complete Writings on Art*, London 1982, p.115, 'There also exists a

Russian manuscript and a Russian typescript, each different from the other, and different again from any of the published versions of the book.' With the emergence of Cubism and awareness of the music of Arnold Schoenberg, Kandinsky's text underwent a further revision prior to publication in Germany.

9 The first *Blaue Reiter* exhibition, Heinrich Thannhauser's gallery, Munich, 18 December 1911 – 3 January 1912.

10 A fourth German edition was due to appear in 1914, but the outbreak of war frustrated these plans. Lindsay and Vergo 1982, p.115 reports that Kandinsky intended to make further changes to this fourth edition as 'a manuscript headed "Kleine Anderungen zum 'Geistigen'" (Small Changes to the 'Spiritual') was found in his studio at Neuilly, and has been partly published by Lindsay'.

11 Frank Rutter (1876–1937) was art critic for the *Sunday Times* from 1903 until his death in 1937. In addition to being the driving force behind the AAA (Chairman, 1912–20), Rutter was also the Director of Leeds City Art Gallery, 1912–17. He wrote an early book on the Post-Impressionists, *Revolution in Art: an Introduction to the Study of Cézanne, Gauguin, Van Gogh and Other Modern Painters*, London 1910, and published an influential periodical, *Art and Letters*, between 1917 and 1920. The AAA was founded in early 1908 as a non-jury exhibiting salon modelled on the Salon des Indépendants in France.

12 It would appear from Rutter's own chronicle, *Art in my Time* (London 1933), that he and others in Britain first became aware of Kandinsky's work following the artist's representation at the AAA's second London Salon held at the Royal Albert Hall in July 1909. Kandinsky exhibited two 'large' works, *Jaune et Rose* (cat.1068) [*Yellow Cliff*; present location unknown] and *Paysage* (cat.1069) [possibly *Landschaft*, 1908–9; present location unknown], each priced at £50. These oils were shown in Section XIX in the Main Gallery alongside artists such as Ethel Sands, whilst twelve of his engravings, ranging in price from £1 to £2 each (cat.1923), were shown in a separate section alongside John Copley's prints. As Rutter recalls in his memoirs, 'Among the new exhibitors [was] the Munich artist Wassily Kandinsky, who originated the Expressionist movement. His abstract, non-representative designs excited a large amount of interest and heated debate. They were bought during the exhibition by M. Sadleir, now a well known novelist, then just down from Balliol' (p.137). Rutter seems to have confused MTHS's purchase of works by Kandinsky at this date with a later one in 1911.

13 These sixteen small texts, though not specifically stated, would appear to be the prose poems for *Klänge* (*Sounds*). Interestingly, there are fifteen typescript copies (including one duplicate) of Kandinsky's poems in the Sadler archives (TGA 8221.8.3). These typescripts, some with Kandinsky's hand-written annotations, may have been sent to MES once Rutter had heard of his interest in the artist.

14 The album Kandinsky refers to may either be *Sounds* or the almanac edited by Kandinsky and Franz Marc as *Der Blaue Reiter* (Munich 1912); two months prior to Rutter's card,

Kandinsky had initially written to Marc with the idea that they should begin to collect material for an almanac or yearbook.

15 The Russian composer, Thomas von Hartmann, who wrote a text 'On Anarchy in Music' for the *Blaue Reiter* almanac (pp.43–7) and is listed as providing the musical portion to Kandinsky's *Yellow Sound* (p.115).

16 *Izobrazitel'noe iskusstvo-zhurnal otdela izobr. iskusstv komimissariata narodnogo prosveshcheniia*, no.1, Petrograd 1919, pp.39–49.

17 To Kandinsky from Frank Rutter, Allied Artists' Association, 67–9 Chancery Lane, London, 31 August 1911 (the Gabriele Münter und Johannes Eichner Stiftung, Munich).

18 These woodcuts are the ones that MTHS purchased from the fourth AAA London Salon held at the Royal Albert Hall in July 1911 and mentioned in his memoir of his father (Sadleir 1949, p.237) as 'small square woodcuts semi-representational, and with an element of hierarchical rigidity'. Listed in the catalogue as 'Six Woodcuts and Album with Text' (cat.1201), they were offered for sale for £1 each. The AAA's commission was 5%, which in this case amounted to four shillings, whilst the framing costs (undertaken by 'Chenil et Cie.') amounted to ten shillings and sixpence.

19 Sadleir 1949, p.237.

20 To Kandinsky from MTHS, 'Eastwood', Weybridge, 2 October 1911 (the Gabriele Münter und Johannes Eichner Stiftung, Munich). *Rhythm*, the first issue of which appeared in the summer of 1911, was edited by J.M. Murray and Katherine Mansfield. MTHS contributed regularly; the second issue (Autumn 1911) ran his review of Vincent van Gogh's letters. Other important articles by MTHS, during this pre-war period, included 'L'Esprit Veille (On Gauguin)', (winter 1911); and 'After Gauguin', (spring 1912), which made reference to Kandinsky's theories.

21 There is no evidence that one was subsequently published by MTHS in *Rhythm* or in any other periodical.

22 The poet Rupert Brooke (1887–1915), after leaving King's College, Cambridge, travelled to Munich to learn German, from January to May 1911. Through an introduction from E.J. Dent, Brooke was able to call on the painter Frau Ewald and her son Paul, then a student of physics and later an artist, both of whom lived in München-Schwabing. Early in February, Brooke moved his lodgings to be near their studio apartment in Friedrichstrasse and often visited them for meals. It was the Ewalds who introduced Brooke to Karl Wolfskehl, patron of poets and modernist painters. Although Frau Ewald may have introduced Brooke to Kandinsky, the two probably met at one of Wolfskehl's salons, which were normally held on the first Thursday of each month.

23 This four-page brochure/press release contains a list of participants and both versions of the texts for the exhibition

catalogue of *The First Exhibition of the Blaue Reiter*, plus an advertisement for the almanac. The list of participants for the exhibition omits Eugen Kahler and Jean Niestlé, who both took part, and the advertisement differs from the one reproduced in Lindsay and Vergo 1982, p.849 in a number of respects. The contents are arranged differently and N. Briusov's article, 'Musicology', is omitted, whilst the list of reproductions does not include Jawlensky and Werefkin.

24 As mentioned in the main text, *Concerning the Spiritual in Art* was not published until December 1911.

25 'Construction in Painting' did not appear in the almanac, unless this title was an earlier one for 'On the Question of Form', which did appear. In addition to his play *Yellow Sound*, a third article by Kandinsky, 'On Stage Composition', also appeared.

26 The text headed 'Le Chevalier Bleu Organe d'un art' was found – seemingly unattached to any of Kandinsky's letters – in Sadler's archives (TGA 8221.8.4). It appears to follow, with minor variations, the text published in *The Blaue Reiter Almanac Edited by Wassily Kandinsky and Franz Marc: Documentary Edition by Klaus Lankheit*, London 1974, pp.250–1.

27 There are no letters from this period in the Gabriele Münter und Johannes Eichner Stiftung, Munich.

28 Lindsay and Vergo 1982, p.883.

29 Kandinsky devoted considerable space to an analysis of Maeterlinck's use of words to manipulate moods 'artistically' by removing the external reference from words by constant repetition and by dislocation from the narrative; similar to the way Kandinsky veiled his own images in paintings. In addition, Kandinsky translated Maeterlinck's suggestions for the dematerialisation of words into his own proposal for the dematerialisation of objects, writing 'Just as each spoken word (tree, sky, man) has an inner vibration, so does each represented object'. Ibid., p.74.

30 They would often recite them at their soirées. However, only 'Sehen' ('See') and 'Blick und Blitz' ('Gaze and Thunderbolt') were published in *Cabaret Voltaire*, June 1916.

31 This was an extraordinarily busy period for Kandinsky with exhibitions by the editorial board of *Der Blaue Reiter* in Munich, Cologne and Berlin; the publication of the first and second editions of *Concerning the Spiritual in Art*; and the appearance of the *Blaue Reiter* almanac. In addition, Kandinsky participated in a number of mixed exhibitions, notably the fourth exhibition of the Neue Secession in Berlin; the Salon des Indépendants in Paris; and the Sonderbund Internationale Kunstausslung in Cologne.

32 To MTHS from Kandinsky, Murnau, 13 August 1912 (TGA 8221.6.20).

33 In one of MES's letters to his wife, dated 20 August 1912, he gives a taste of their conversation, when referring to a later lecture on improvisation by the pioneer of Eurhythmics,

Dalcroze: 'He talked as Kandinsky might about music & colour'. (TGA 8221.4.15).

34 TGA 8221.4.13 and quoted in Sadleir 1949, pp.237–8.

35 Kandinsky's works listed in MES's catalogue of his collection, December 1934 (TGA 8221.1.1), include the oil paintings *Composition, 1913*, subtitled *War of the Worlds* [*Section 2 for Composition VII*, cat.475 in *Kandinsky*: Catalogue Raisonné *of the Oil Paintings, Volume One: 1900–1915'*, Hans K. Roethal and Jean K. Benjamin, London 1982]; and the watercolours *Russian Composition, 1915*, subtitled *Faith of Russia* [*Untitled*, December 1915, cat.429 in *Kandinsky Watercolours* Catalogue Raisonné, *vol.1, 1900–1921*, Vivian Endicott Barnett, London 1992]; *Composition, 1911*, subtitled *Bavaria*; *Composition, 1912*, subtitled *Flowers*; *Composition, 1912*, subtitled *Asparagus*; and an etching, *Composition No. II, 1916*.

MTHS owned the six woodcuts bought at the fourth London Salon of the AAA in 1911, a watercolour mentioned in a letter from Kandinsky dated 12 August 1913 (TGA 8221.6.30), and possibly a sketch for the American commission mentioned in Kandinsky's letter to MTHS, 14 June 1914 (TGA 8221.6.34).

By January 1913, visitors to Buckingham House, Leeds, had included Frank Rutter, Geoffrey Blackwell, C.J. Holmes and John Galsworthy (Sadleir 1949, p.250). And in a letter to Kandinsky dated 11 March 1913 MES writes: 'Mr Roger Fry has been staying with us and was deeply interested in your drawings. He asked if I would lend them for an exhibition which he and some friends are organising next week in London [the first Grafton Group exhibition, Alpine Club, March 1913], and of course I gladly consented.' (The Gabriele Münter und Johannes Eichner Stiftung, Munich).

36 After that first visit, MES wrote: 'Today we have had the great pleasure of seeing some of your drawings and of Frau Kandinsky's at Go[l]tz's [Kandinsky's dealer]. We shall value very much the ones which are being sent to us in England – especially yours and hers. The more I studied your drawings, the more I felt that they conveyed to me. But I am only a beginner, and hope that I may understand more of your deeper meaning as I learn to know your drawings better.' (Letter dated 17 August 1912 and written in Germany but posted from Leeds in the Gabriele Münter und Johannes Eichner Stiftung, Munich.)

37 'On the Question of Form', *Der Blaue Reiter*, Munich 1912, pp.74–102.

38 Kandinsky obviously hoped that an English version might be published; not realised until Klaus Lankheit's edition in 1974 (see note 26).

39 It was vitally important that the second edition was used for the translation as this contained Kandinsky's most up-to-date thoughts.

40 From 16–26 October Kandinsky stayed in Odessa and from 27 October – 13 December in Moscow. Kandinsky had particular reason to travel to Odessa, as his great friend

the sculptor Vladimir Izdebsky lived there running a publishing business and organising international exhibitions. Izdebsky intended to publish a selection of Kandinsky's poems for *Sounds* (including 'Landscape' – Appendix A) 'and there were plans for a Russian monograph on Kandinsky or possibly an album with reproductions of his works' (Lindsay and Vergo 1982, p.84).

41 Kandinsky's first solo exhibition opened at Galerie Der Sturm, Berlin on 6 October (until 28 October) and then toured to other German and European cities. The catalogue was not in the Sadler archives when acquired by the Tate Gallery.

42 To Kandinsky from MTHS, Ingram House, Stockwell Road, London, 2 December 1912 (the Gabriele Münter und Johannes Eichner Stiftung, Munich).

43 Kandinsky participated in the Armory Show, New York in 1913 with *Improvisation No.27* (cat.213), which was lent by Hans Goltz and later bought by Alfred Stieglitz.

44 Presumably the works by Kandinsky shown at Gallery Oldenzeel, Rotterdam, 5–18 November, as part of his touring exhibition. This solo exhibition never came to England, though three of his works were displayed at the sixth AAA London Salon, Royal Albert Hall, July 1913. These were listed in the catalogue as *Improvisation No.29*, £50 (cat.285); *Improvisation No.30*, £40 (cat.286); and *Landscape with Two Poplars*, £25 (cat.287).

45 To MTHS from Kandinsky, [Ainmillerstr. 36/1, Munich?], 20 December 1912 (TGA 8221.6.23).

46 Due to the outbreak of the First World War, the proposed Dutch, French and Russian translations never appeared.

47 This important passage illustrates how far Kandinsky was travelling in his attempts to move from objects in paintings to pure abstract form, and tends to refute the assertion, that Kandinsky himself made in the German magazine *Das Kunstblatt* in 1919, that he produced his first wholly abstract painting in 1911.

48 To MES from Kandinsky, Ainmillerstr. 36/1, Munich, 24 February 1913 (TGA 8221.2.49).

49 The correspondence relating to this proposed exhibition does not appear in the extant records of the Goupil Gallery (TGA 739 and TGA 8314).

50 To Kandinsky from MES, The University, Leeds, 11 March 1913 (TGA 8221.2.50).

51 Kandinsky probably had in mind three avant-garde Russian composers: Alexander Skryabin (also interested in theosophy), who developed a theory of association between notes and colours best expressed in his large orchestral work, 'Prométhée'; Igor Stravinsky's music for ballets such as 'The Firebird' (1910), 'Petrushka' (1911) and 'The Rite of Spring' (1912); and, of course, Kandinsky's friend and musical

theorist, Arnold Schoenberg.

52 Lindsay and Vergo 1982, p.12.

53 The sixth AAA London Salon exhibition, ibid.

54 To Kandinsky from MTHS, 10 Orange St, Leicester Square, London, 24 July 1913 (the Gabriele Münter und Johannes Eichner Stiftung, Munich).

55 *Rhythm* [fourth issue], Spring 1912, containing MTHS's article 'After Gauguin', where he outlines, in very basic terms, some of Kandinsky's theories for the first time in English. This was also the first time that references to the German edition of *Concerning the Spiritual in Art* and *Der Blaue Reiter* appeared in English.

56 Possibly one of the members of the committee that published *Concerning the Spiritual in Art* in Petrograd, 1914.

57 Either immediately following the exhibition or shortly thereafter, *Improvisation 29* and *Improvisation 30* entered Arthur Jerome Eddy's collection, as did the third work, *Landscape with Two Poplars*, after being exhibited in *Erste Gesamt-Ausstellung*, Galerie Hans Goltz, Munich, October 1912.

58 *Kandinsky 1901–1913*, Berlin 1913. The book, published by Der Sturm, included Kandinsky's 'Reminiscences' and his descriptions of three paintings, *Composition 4*, *Composition 6* and *Picture with White Edge*.

59 There is no work listed for MTHS in Barnett 1992. The only possibility for this date, and the only one with an unclear early provenance, would be *Water-colour No.2*, p.269.

60 To MTHS from Kandinsky, from Moscow, 7 August 1913 (TGA 8221.6.30).

61 The changes in illustrations were carried out and reflect Kandinsky's preference for the most recent of his paintings to be reproduced and his desire to highlight the geographical spread of his patrons.

62 To MES from Kandinsky, Ainmillerstr. 36/1, Munich, 22 October 1913 (TGA 8221.2.51).

63 To Kandinsky from MTHS, Houghton Mifflin Company, 4 Park St, Boston, 27 October 1913 (the Gabriele Münter und Johannes Eichner Stiftung, Munich).

64 Possibly, work(s) in a private collection or exhibited at Thomas Agnew and Sons, 14 Exchange St, Manchester.

65 *Section 2 for Composition VII (Centre and Corners)*, 1913, now in the Albright-Knox Art Gallery, Buffalo, USA.

66 Arthur J. Eddy 'probably owned, at one time, over one hundred of Kandinsky's works', as quoted in Hans K. Roethel, in collaboration with Jean K. Benjamin, *Kandinsky*, Oxford 1979.

67 Arthur Jerome Eddy, *Cubists and Post-Impressionism*, London and Chicago 1914.

68 An excerpt from *Concerning the Spiritual in Art* was published in *Camera Work*, no.39, July 1912, p.34.

69 Most probably for an unrealised *Encyclopaedia of Fine Arts* to be published by a committee that included Kandinsky, the architect I.V. Zheltovsky and the poet V. Shershenevich.

70 *Kandinsky, 1901–1913*, Berlin 1913. The Russian version, *Steps*, was published in Moscow by IZO, the Fine Arts Department of the Commissariat of Enlightenment, but not until 1918. With its four vignettes and twenty-five reproductions, it seems to be an amalgamation of the Berlin publication and the other Russian publication mentioned above.

71 To Kandinsky from MTHS, Houghton Mifflin Company, 4 Park Street, Boston, 8 January 1914 (the Gabriele Münter und Johannes Eichner Stiftung, Munich).

72 Ibid.

73 To MES from Kandinsky, Ainmillerstr. 36/1, Munich, 6 April 1914 (TGA 8221.2.51).

74 To Kandinsky from MTHS, 10 Orange St, Leicester Square, London, 6 April 1914 (the Gabriele Münter und Johannes Eichner Stiftung, Munich).

75 The seventh AAA London Salon exhibition, Holland Park Hall W., 12 June – 2 July 1914. Kandinsky showed three works, listed in the late additions section of the catalogue as: no.1558 *Picture with Yellow Colouring* [*Little Painting with Yellow*; bought by J.A. Eddy and now in the Philadelphia Museum of Art, The Louise and Walter Arensberg Collection]; no.1559 *Study for Improvization No. 7*, 1914 [*Study for Improvisation 7*, actually dated 1910; Yale University Art Gallery, Collection Société Anonyme, New Haven]; and no.1560 *Painting* [present whereabouts unknown].

76 A series of four panels commissioned, through Stieglitz, by Edwin R. Campbell for the circular reception hall of his apartment at 635 Park Avenue, New York for the sum of 2,000 marks.

77 There is no evidence that MTHS received such a sketch.

78 To Kandinsky from MTHS, 10 Orange St, [Leicester Square, London], 22 June 1914 (the Gabriele Münter und Johannes Eichner Stiftung, Munich).

79 Letters by Kandinsky from Switzerland are rare. 'Except for exchanging a few letters with Paul Klee, he cut himself off all contact with the world' (Lindsay and Vergo 1982, p.26).

80 The *Blaue Reiter* almanac, p.12.

81 'kuda idet "novoe" iskusstvo' in *Odesskie novosti*, 9 February 1911, p.3.

82 The exhibition catalogue *Modern Art in Britain, 1910–14*, Barbican Art Gallery, London, 20 February – 26 May 1997, researched and selected by Dr Anna Greutzner Robins and published by Merrell Holberton, gives an excellent survey of this period.

83 Ernest Percyval Tudor-Hart (1874–1954) studied art at the Académie Julian and at the École des Beaux-Arts in the 1890s.

84 Léo Belmonte (1870–1956), French artist; Sándor Nagy (1869–1950), Hungarian painter of landscapes and symbolic frescoes, designer of tapestries and book illustrations, who studied in Budapest, Rome and Paris. Together with Aladár Körösfói-Kriesch, he co-founded the art school in Gödölló, Hungary and was the leader of a carpet weaving firm there; Aladár Körösfói-Kriesch (1863–1920), Hungarian painter, designer, decorative artist and writer, who studied in Budapest, Munich, Venice and Rome. Like Kandinsky, he collected folk art and used such motifs in his own paintings. From 1893 Körösfói-Kriesch spent his summers in the Transylvanian town of Diód and gathered around himself a group of painter friends, including Sándor Nagy, who shared his regard for folk art as an ideal form of expression and for Tolstoy's ideas. Körösfói-Kriesch was also visited here by his artist friends Ernest Percyval Tudor-Hart, the Austrian Tom Richard von Dreger (1868–1948) and Léo Belmonte. In 1901 Körösfói-Kriesch and Nagy founded an artist's colony in the village of Gödölló, Hungary.

85 Alasdair Alpin MacGregor, *Percyval Tudor-Hart: Portrait of an Artist*, London 1961, p.95.

86 It was at this address, Ainmillerstrasse 36/1, in Munich that the Russian Constuctivist sculptor, Naum Gabo (1890–1977) would meet Kandinsky in 1912.

87 For instance, an anonymous reviewer in the *Nation*, July 1908, wrote: 'At this season of the year in London most people would say that the crying need was to diminish, not to increase, the number of art exhibitions. It stands to reason that such a collection must degenerate into a hopeless hodge-podge, an array of good, bad, and indifferent.'

88 From an analysis of the index to exhibitors to this inaugural exhibition over one hundred of the 800 artists sent work from outside Britain. Unsurprisingly, most of these artists were working in Paris (including many ex-patriots), though there is a scattering of painters and sculptors from Austria, Italy, Germany, Poland, Spain and as far away as India. The same geographical spread continues from 1909 when Kandinsky exhibits for the first time until his last appearance in 1914 (perversely he is mistakenly listed as Daisy Katherine Rolls in the 1912 catalogue entry). Notable artsists from abroad who exhibited up to the eighth AAA exhibition in 1916 include Alfred Maurer (1908), Rodric O'Conor (1908), Theophile Alexandre Steinlen (1908), Abanendraneth Tagore (1908), Jack B. Yeats

(1910), Constantin Brancusi (1913), Henri Gaudier-Brzeska (1913), Anne Estelle Rice (1913), Ossip 'Joe' Zadkine (1913).

89 Henri Bergson, *L'Evolution créatrice*, Paris 1907, translated as *Creative Evolution* by Arthur Mitchell, London 1911; and Benedetto Croce, *Estetica come scienza dell' espressione e linguistica generale*, Bari 1908, translated as *Aesthetic as Science of Expression and General Linguistic*, London 1909.

90 'Aims and Ideals', *Rhythm*, vol.1, no.1, Summer 1911, p.34.

91 'Fauvism and a Fauve', ibid., pp.14–18.

92 'L'Esprit Veille', *Rhythm*, vol.1, no.3, Winter 1911.

93 *The International Exhibition of Modern Art* held at the 69th Regiment Armory building, New York City, 1913.

94 Alpin MacGregor 1961, p.96.

95 John E. Bowlt and Rose Carol Washton Long, *The Life of Wassilii Kandinsky in Russian Art: A Study of 'On the Spiritual in Art'*, Newtonville, Mass., 1980, p.43.

96 See footnotes 20 and 55. In his article 'After Gauguin' that appeared in the early months of 1912, Sadleir wrote: 'From this book two main contentions arise. The first is virually a statement of Pantheism, that there exists a 'something' behind externals common in nature and humanity alike. That is what Wordsworth believed, but while he approached the question subjectively, contenting himself with describing the experiences of his mood-communion with the nature around him, the new art is to act as an intermediary for others, to harmonise the inner *Klang* [resonance] of external nature with that of humanity, it being the artist's task to divine and elicit the common essentials underlying both. The second contention follows naturally from the first. An art intent on expressing the inner soul of persons and things will inevitably stray from the outer conventions of form and colour. That is to say, it will be definitely unnaturalistic, anti-materialist.' Sadleir had also published a brief article on Kandinsky's work and theories in *Art News*, 9 March 1912.

97 C. R. W. Nevinson, *Paint and Prejudice*, London 1937, p.43.

98 Hilda Carline (1889–1950) joined her brothers in 1915.

99 Rupert Brooke, 'The Night Journey', *Rhythm*, vol.2, no.1, Spring 1912.

100 Roger Fry, 'The Allied Artists', *Nation*, 2 August 1913, p.676–7.

101 Vanessa Bell and Duncan Grant were named as co-directors with Roger Fry.

102 *Blast*, no.1, London, 20 June 1914, pp.119–25.

103 Ibid.

104 Ibid., p.142.

105 Ibid., p.138 (note by Lewis entitled 'Feng Shui and Contemporary Form').

106 *Blast*, no.2, London, July 1915, p.44.

107 Ibid.

108 He spent the war assisting Tudor-Hart and Richard Carline camouflaging battleships.

109 I. A. Richards, C. K. Ogden, J. Wood, *The Foundations of Aesthetics*, London 1922; second edition with revised preface, New York 1925. The text was first published by the three co-authors as 'The Sense of Beauty', *Cambridge Magazine*, 10/2 (January–March 1921), pp.73–93, and later used by I. A. Richards and C. K. Ogden in Chapter 7 ('The Meaning of Beauty') of *The Meaning of Meaning: A Study of the Influence of Language upon Thought and of the Science of Symbolism* (London and New York 1923).

110 Ibid., p.73.

111 Ibid., pp.74–5.

112 The school was founded by Cyril Edward Power, Iain MacNab and Claude Flight, with Sybil Andrews as the School Secretary. The principal lecturers were Power on the subject of 'The Form and Structure of Buildings, Historical Ornament and Symbolism and Outline of Architectural Styles', and Rutter on 'Modern Painters from Cézanne to Picasso'. It became an influential centre for studying the art of the linocut.

113 Exhibition organised by the Anglo-German Club in London and the Hamburger Kunstverein, with the article written by Dr Hildebrand Gurlitt, curator of the Kunsthalle.

114 The publication of *AXIS: A Quarterly Review of Contemporary 'Abstract' Painting and Sculpture* was announced by Paul Nash in *The Times* (12 June 1933) and described as 'the expression of a truly contemporary spirit'.

115 *Art Now*, London 1934, p.116. Read, in a footnote to this passage, gives full acknowledgement to Kandinsky, stating that he 'was the first to develop a complete theory of modern abstract art. He represented the most abstract element in the "Blaue Reiter" Group (which included also Franz Marc and Paul Klee) and his book "Uber das Geistige in der Kunst", published in 1912 and translated in 1914 as "The Art of Spiritual Harmony" (Constable, London) is one of the earliest and remains one of the best, approaches to the subject'.

116 *Abstract and Concrete*, Gallery 41, Oxford, 15–22 February 1936, then toured to the University of Liverpool School of Architecture, 2–14 March 1936; Alex Reid and Lefevre, Ltd, London, April 1936; and Gordon Fraser Gallery, Cambridge, 28 May–13 June 1936.

PHOTO CREDITS

INDEX

Byzantine art xxx, xxxiii, 75n, 110n